IMAGES
of America

SAN FRANCISCO
FIRE DEPARTMENT

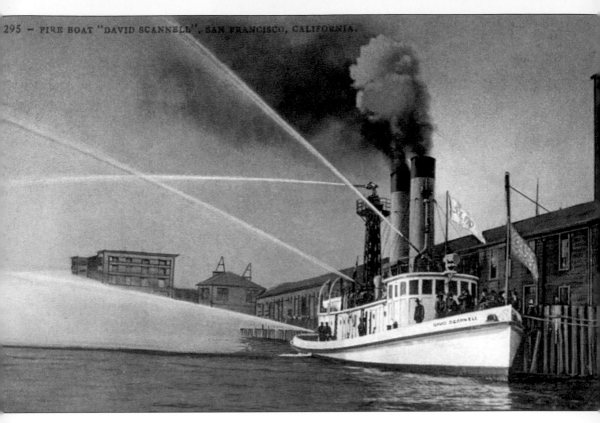

Here is a tower that protects our bay,
A floating tower with a chilling spray.
To douse the anger of some darting flame,
And put the menace of dread fire to shame.
Who mans this tower and controls this ship,
When she must steam into some blazing slip.
Must be men of courage possessed by very few,
The members of our fireboat's crew.

Jack Densham, SFFD, 1935
Poem courtesy San Francisco Fire Department, Pioneer Memorial Museum,
and postcard courtesy author.

On the Cover: This striking image shows the San Francisco Fire Department (SFFD) responding to a three-alarm apartment house blaze in September 1952 at the famous Haight and Ashbury intersection, ground zero of the "Summer of Love" in 1967. This afternoon fire, on a bright and sunny day, brought out 22 pieces of equipment of fire fighting apparatus. One woman who was living on the top floor suffered burns before firemen rescued her. Several men and boys watched the drama unfold and a few even brought their cameras.

IMAGES
of America
SAN FRANCISCO
FIRE DEPARTMENT

John Garvey

ARCADIA

Published by Arcadia Publishing,
an imprint of Tempus Publishing, Inc.
Charleston SC, Chicago, Portsmouth NH,
San Francisco

Printed in Great Britain.

Library of Congress Catalog Card Number: 2003105836

For all general information contact Arcadia Publishing at:
Telephone 843-853-2070
Fax 843-853-0044
E-Mail sales@arcadiapublishing.com
For customer service and orders:
Toll-Free 1-888-313-2665

Visit us on the internet at http://www.arcadiapublishing.com

To my mother Betty Garvey (1928–2003) a volunteer San Francisco City Guide, who donated her time at the SFFD Pioneer Memorial Museum and at the Palace Hotel. I got her interested in the museum and she got me interested in starting the SFFD Oral History Program with firefighters in the early 1990s, initially at the Diamond Senior Center, now the Betty Garvey Diamond Senior Center, in Eureka Valley, better known today as the Castro. Because of this I had to opportunity to interview Chief William Murray, who had a 50-year career with the SFFD and was the founder of the SFFD Museum, before his passing. Most rewarding for me was when the son of SFFD firefighter William P. (Bill) Maloney, Battalion Chief George Maloney, told me after his father's death, "I thought I knew everything about my father, but he told you things I never knew, and we were both firefighters. Thank you." This book is also dedicated to my longtime track and field coach Mike Lewis, SFFD retired. Mike, like most firefighters, gave back to the community by donating thousands of hours on his days off to helping me and others achieve goals in sports, college, and life. The result of these two people's influence is, in my case, a bachelor's degree from the University of Maryland, a master's degree from San Diego State University in history, and this book on the special people we call SFFD firefighters and paramedics.

CONTENTS

ACKNOWLEDGMENTS

The author would like to thank SFFD Chief Mario Trevino and Lt. Barry Wong for their assistance with this project. Thanks also goes to Patricia Akre, photographic curator at the San Francisco Public Library; Selby Collins with the San Francisco History Room, and Peter Fairfield with Gamma Labs.

The author would also like to thank the following people associated with the SFFD Museum: Bill Koenig, Bob Kretuzberger, Eric Passler, and Al Sassus. Also, the museum's docents Chuck Burwell, Flavio Cadenenai, Barbara Casey, Ed Fourcault, Marina Garris, Karen Hanning, Virginia Jones, Frances Marvin, Mike Minor, Richard Reutlinger, Maureen Sarment, and Bruce Shelton; SFFD firefighters from the Sports Palace Gym Sarah Coe and Jerry Winston who encouraged me to be strong; and Arcadia Publishing's Christine Talbot Riley, Keith Ulrich, and Sarah Wassell. To my wife, Kyoko, for allowing me to spend time on this project while she parented our children.

Most importantly, to the SFFD paramedics who in June 2000 brought me to the emergency room via city ambulance after I had an anaphylactic allergic reaction to a nectarine. I believe I am alive today due to their actions.

The author will donate a portion of the proceeds from the sale of this book to the San Francisco Fire Department's Toy program.

INTRODUCTION

The San Francisco Fire Department (SFFD) is a first-class organization, very selective, and whenever a recruitment test is offered swarms of people invade Brooks Hall, the Moscone Center, or the Cow Palace to participate.

If hired on to the department, recruits soon learn that San Francisco is not an easy place to work. The city is second only to New York City in population density and roadways in the United States. The five busiest firehouses in the city are the following: (1) Fire Station #13 at 530 Sansome Street in the Financial District, (2) Fire Station #2 at 1340 Powell Street in Chinatown, (3) Fire Station #1 at 676 Howard Street near the Moscone Center, (4) Fire Station #36 at 109 Oak Street in the Civic Center (SFFD's only hazardous materials vehicle is also assigned here), and (5) Fire Station #8 at 36 Bluxome Street in Mission Bay. If those are not a challenge enough, there is always Station #34, the Cliff Rescue Unit, where SFFD personnel often rescue people at Ocean Beach where the undertow has killed many, or at Baker Beach where a Great White shark killed a man in 1959.

San Francisco is the great city it is today due in part to the women and men of the SFFD who have made sacrifices for all of us. One thing that will jump out at anyone who reads this book is that firefighting is a very dangerous job and that the people in our communities we know as firefighters are very special. It has been my pleasure to be a volunteer City Guide docent at the SFFD museum since 1989. Enjoy this book, but know that any credit due should go to the SFFD firefighters and paramedics who are on duty 24 hours a day, 7 days a week, 365 days a year. They all give 110 percent, and those who have died in the line of duty have given even more.

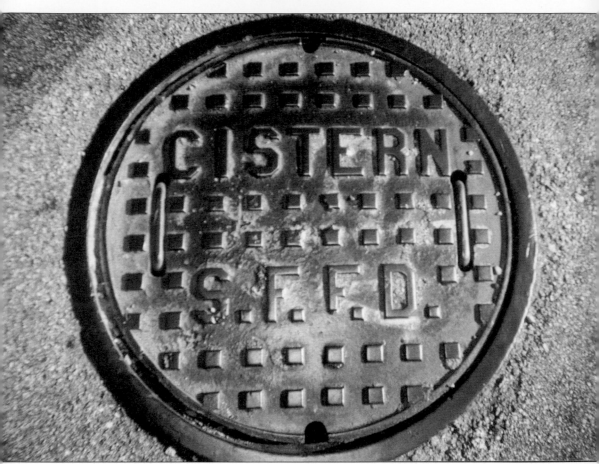

This cistern has the acronym for the San Francisco Fire Department, "SFFD." (Courtesy author.)

SFFD Mission Statement

"The mission of the Fire Department is to protect the lives and property of the people of San Francisco from fires, natural disasters and hazardous materials incidents; to save lives by providing emergency medical services; and to provide a work environment that values cultural diversity and is free of harassment and discrimination." (Courtesy SFFD.)

One
1849–1900

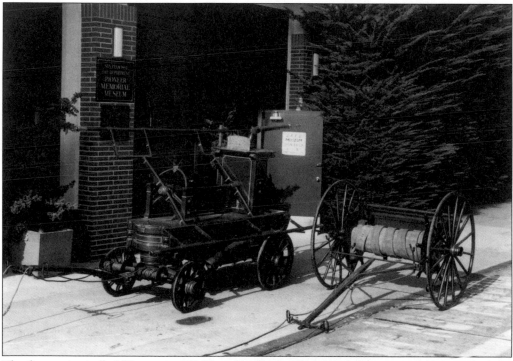

The fire engine called "Protection" belonged to Engine Protection Company #2 and was built by James Smith of New York c. 1810. It was one of the first three engines in San Francisco, all of which had been in service in New York City for 35 years. They were used in San Francisco from 1849 and in the 1860s protection was sold to New Almaden, near San Jose. In 1979, the San Francisco Hook and Ladder Society had the vehicle restored, and since that time it has participated in events such as musters and civic events. In 1982 the engine won the California Fireman's Muster Association Class II, hand-pumping state championship with a distance of 130 feet, 9 inches. (Courtesy Richard B. Hansen and San Francisco History Center, San Francisco Public Library.)

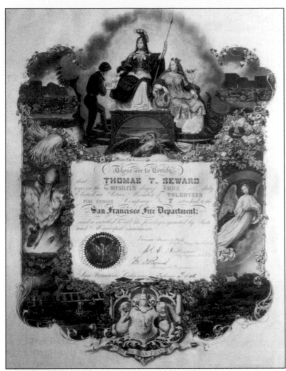

This decorative certificate given to volunteer Thomas T. Seward was designed by German immigrant brothers Charles and Arthur Nahl, who also designed the state flag and great seal of California. It was once customary that those joining the St. Francis Hook and Ladder Society were given a reproduction of this certificate, with their name printed on it, suitable for framing. The St. Francis Hook and Ladder Society is a non-profit organization that serves as the historical arm of the SFFD and, through the volunteer efforts of its members, has helped to continue to operate the fire museum, since its formation in 1974. (Courtesy San Francisco History Center, San Francisco Public Library.)

In 1848 the first cry of gold was heard in Coloma, California, and by 1849, the San Francisco Bay was full of the ships of the fortune seekers. The San Francisco Volunteer Fire Department was born in that same year on Christmas Eve, and 22 companies were formed. Most companies consisted of volunteers with similar heritages; for example, French immigrants organized Lafayette, the Irish began Hibernia, and the Germans established Knickerbocker. Not long after the department's establishment, the second of six major fires hit the city between 1849 and 1851. One of the conflagrations destroyed 3,000 buildings. San Francisco residents were soon required to keep six leather buckets full of water at all times to extinguish any fires. (Courtesy San Francisco History Center, San Francisco Public Library.)

One of the first U.S. senators from California, David C. Broderick, was foreman of Empire Engine Company #7 during San Francisco's early fire history. The Irish-born New York saloon keeper and Tammy Hall politician arrived in San Francisco in 1849 and made a small fortune by privately coining slugs with stated face values much higher than their gold content and by dealing in waterfront real estate. A key player in the establishment of the first professional fire department in San Francisco, Broderick is most famous for his September 1859 pistol duel against State Supreme Court Justice David Terry regarding his opposition to slavery. The 39-year-old senator was hit once in the chest and died at a small cottage at Fort Mason three days later. The dual site, near Lake Merced in Daly City, is now a historic landmark. Broderick Street in San Francisco was named in his honor. (Courtesy San Francisco History Center, San Francisco Public Library.)

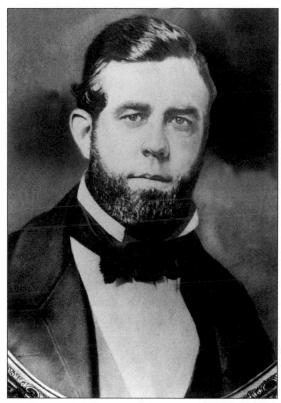

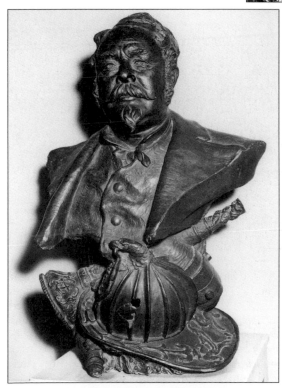

David S. Scannell was the chief engineer of the San Francisco Volunteer Fire Department from 1851 to 1866. In April 1871, he was appointed chief of San Francisco's paid department but was removed from office in 1874 over a squabble between fire commissioners. In 1909 a fireboat was named for Scannell, and it plied the bay with the *Dennis T. Sullivan* until May 1954. Both were built by Risdon Iron Works in San Francisco. (Courtesy San Francisco History Center, San Francisco Public Library.)

11

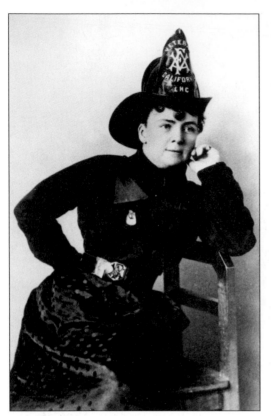

On the day before Christmas 1851, Lillie Coit and her playmates were to attend a children's tea at the Fitzmaurice home. The trio of children stopped to explore a building. A fire was soon discovered, and eight-year-old Lillie and her brother became trapped when a beam fell. Soon, fireman John Boynton, a volunteer with Knickerbocker #5, hacked a hole in the roof to vent the fire and initiate rescue operations. He was able to pull Lillie to safety, but unfortunately, the Fitzmaurice children died. This daring rescue was the origin of a lifelong relationship between Lillie Coit and San Francisco's firefighters. When she was older, she was made an honorary member of Knickerbocker #5. Her household linens bore the words "Number Five," and she often wore an enameled brooch that said the same. Lillie donated $100,000 to beautify San Francisco with the construction of Coit Tower, which was modeled after similar buildings that existed in England and which many think looks like a fireplug. Lillie died in July 1929 but will never be forgotten for her generosity towards the children and widows of firemen. (Courtesy San Francisco History Center, San Francisco Public Library.)

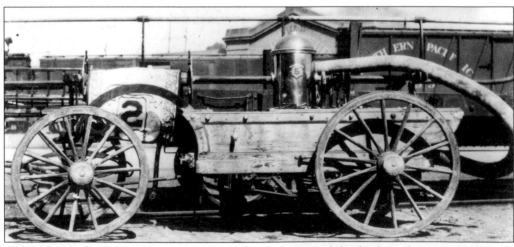

SFFD's Knickerbocker #5 (the name of both the apparatus and the fire house) appears in this July 1930 photograph during a fire apparatus campaign. It was built by James Smith of New York in 1855 for $5,000. Another famous engine was engine #49, built in New York City in 1820. It was previously owned by the eighth President of the United States, Martin Van Buren. (Courtesy San Francisco History Center, San Francisco Public Library.)

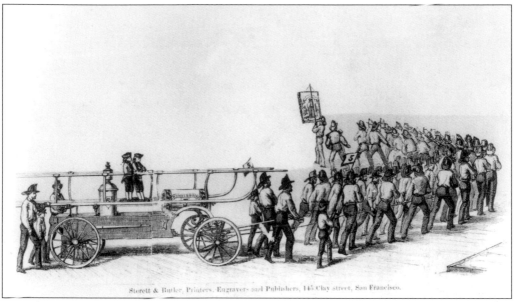

Note the number of men from Knickerbocker #5 required to pull this piece of fire apparatus. This piece of equipment is available for public viewing in the lobby of the SFFD headquarters, which is housed at 698 Second Street in the old high-pressure Pump Station #1 that has been converted in an adaptive reuse project. (Courtesy San Francisco History Center, San Francisco Public Library.)

The Knickerbocker #5 station was located on Sacramento Street between Montgomery and Sansome Streets. Many citizens take advantage of the opportunity to buy old SFFD station houses and convert them to private residences. For example, the late Louise Davies, for whom San Francisco's symphony hall is named, owned 31 Engine at Leavenworth and Green Streets; former California governor and now Oakland mayor Jerry Brown and Hollywood actress Sharon Stone have also owned firehouses. In the late 1980s, a firehouse in the Mission District was even converted to a nightclub/pub, complete with its fire pole for patrons to grasp when they had consumed too many adult beverages. (Courtesy San Francisco History Center, San Francisco Public Library.)

13

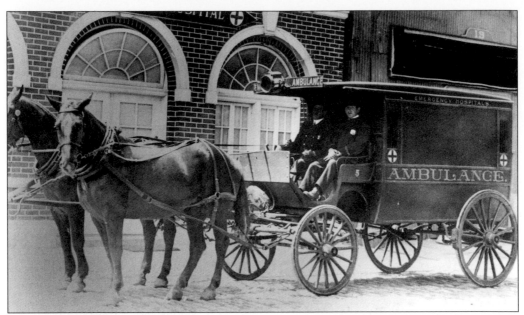

Horses in the SFFD were the subject of a number of interesting coincidences. The first use of a horse by the SFFD took place on August 19, 1863, and the last run by horses to a working fire was August 19, 1921. The last horse officially left the department was August 29, 1921 and the last horse died August 29, 1934. The horses were retired to a California ranch to live out thier lives. The first alarm that involved horses was responded to by three black ones, and the last alarm also involved three black horses. At one point the SFFD owned over 450 horses. One should be mindful that some contend horses were used by firemen since 1849, or perhaps only as early as 1856 to pull pumpers. (Courtesy San Francisco History Center, San Francisco Public Library.)

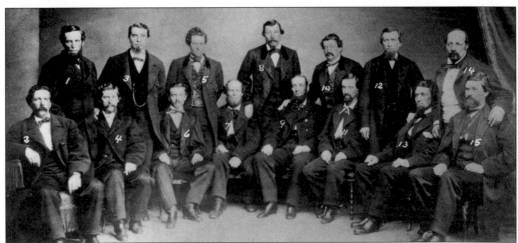

This rare 1868 photo shows "Old Members of the San Francisco Fire Department 1868 the first board of Foreman paid Fire Department." (1.) W.S. Olwell—Hose 1, (2.) J.E. Ross—5 Engine, (3.) R. Cleary—2 Hose, (4.) J.J. Kelley—2 Engine, (5.) N.D. Claffey—8 Hose, (6.) A. Smith—6 Engine,(7.) H.W. Burcher—1 Asst. Chief, (8.) A. Bourgeois—2 Truck, (9.) F.E. Whitney—Chief, (10.) P.V. Denniston—6 Hose, (11.) C.H. Ackerson—2 Asst. Chief, (12.) F. Rosencamp—1 Truck, (13.) M.E. Fitzgibbon—3 Engine, (14.) B. Wolff—4 Hose, and (15.) J.E. Mitchell—4 Engine. (Courtesy San Francisco History Center, San Francisco Public Library.)

Trumpets were used at fires by officers needing to shout commands to firemen, but they were also ceremonially corked at retirement events and filled with fine champagne. This undated photograph shows, from left to right, William B. Firman, Chief David Scannell, and Charles McCann, and was probably taken during Scannell's tenure as chief between 1871 and 1893. (Courtesy San Francisco History Center, San Francisco Public Library.)

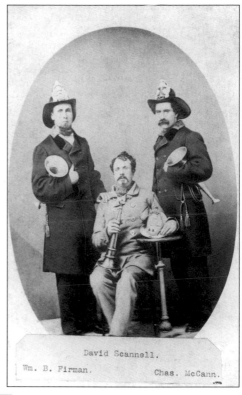

David Scannell.

Wm. B. Firman. Chas. McCann.

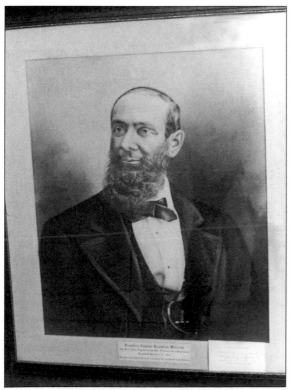

From 1866 to 1871, Franklin Eugene Raymond Whitney served as the first chief engineer of the SFFD, a position for which he earned $4,000 per year. He was also the last person to briefly lead the all-volunteer department and had been a member of the New York City Fire Department before arriving in San Francisco. (Courtesy San Francisco History Center, San Francisco Public Library.)

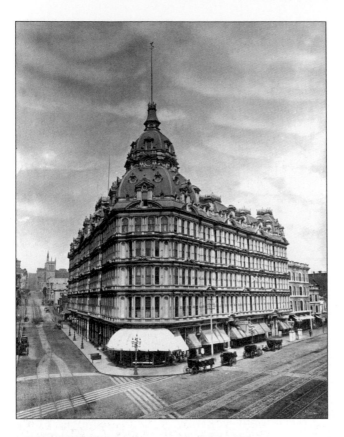

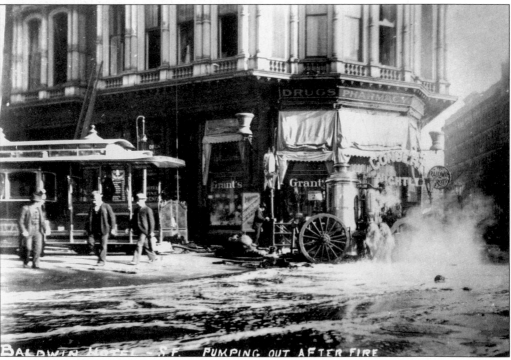

BALDWIN HOTEL - S.F. PUMPING OUT AFTER FIRE

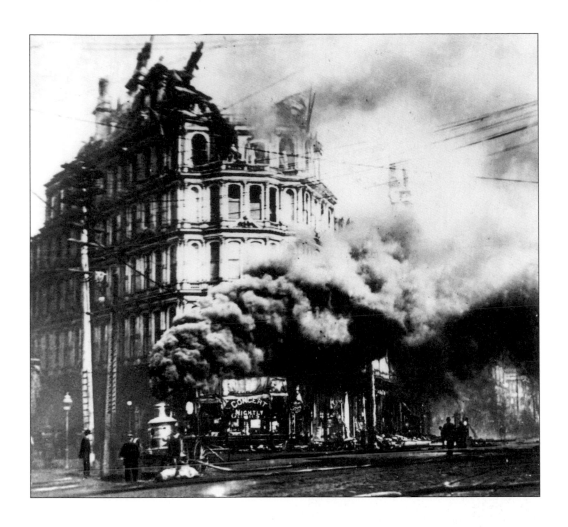

These three photos show the Baldwin Hotel, located at the corner of Powell and Market Streets, in 1878 (opposite, top), during the fire in November 1898 (above), and pumping out water after the fire (opposite, bottom). The owner of the hotel, Elias Jackson Baldwin, was a mining and real estate speculator who spent $3.5 million to construct his monumental hotel and fill it with imported furniture, hardwoods, and tapestries in an effort to outdo the rival Palace Hotel. He advertised the establishment as "the finest west of New York." Before the 1898 fire, the owner's nickname had been "Lucky Baldwin." Unfortunately, the hotel was not insured and was completely destroyed in the blaze. The disastrous fire also exposed the weakness of the domestic water supply in dealing with large, wood-frame buildings. However, Chief Dennis Sullivan had the solution, and he soon became the father of the modern high-pressure water system in San Francisco. (All three photos courtesy San Francisco History Center, San Francisco Public Library.)

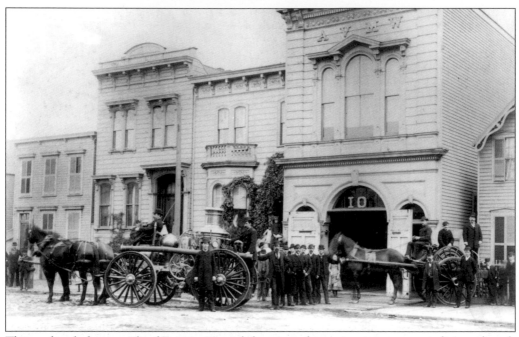

This undated photograph of Engine 10, with horses and steamer, is in poor condition, though now preserved in an archival environment. It is amazing what computer technology can do to bring these brave firemen into the 21st century for us to appreciate. (Courtesy San Francisco History Center, San Francisco Public Library.)

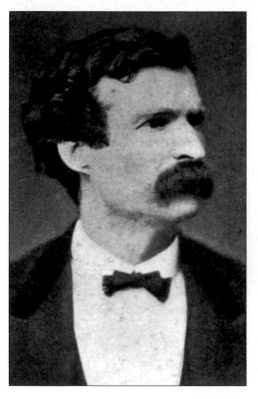

When author Samuel L. Clemens, also known as Mark Twain, was a reporter for one of the daily newspapers in San Francisco he was an associate of a local fireman by the name of Tom Sawyer. Clemens immortalized his friend in the 1876 book *The Adventures of Tom Sawyer*. The original Tom Sawyer was born in New York City on January 1, 1832 and arrived in San Francisco with $11.50 in his pocket in February 1850. He entered the steam shipping business, working as a fireman between the ports of San Juan and Panama, until the steamer he was on was wrecked and sunk. He was credited for saving 90 lives in the disaster. Back in California in 1859, Sawyer tried to make a fortune in the mines, but in 1863 he became a special patrolman and, in 1884, an inspector at the customs house. He soon left public service to open a saloon at 935 Mission Street, an establishment that Clemens frequented. Sawyer had worked as a firefighter in New York City, and while in San Francisco, he assisted in organizing Liberty Hose Company #2 and was elected its foreman, a position he held for three terms. (Courtesy San Francisco History Center, San Francisco Public Library.)

Two
1900–1950

This March 1903 photograph is a significant find because it may contradict the statement that the department did not employ people of Asian heritage until Chinese-American Wylie Low joined in 1963. The gentleman on the far right appears to be of Indian descent. The one vertical row of buttons on his uniform denote his rank as a fireman. In the center of this image, another individual wears two vertical rows of buttons, meaning that he was an officer. (Courtesy Veterans Fireman's Association and San Francisco History Center, San Francisco Public Library.)

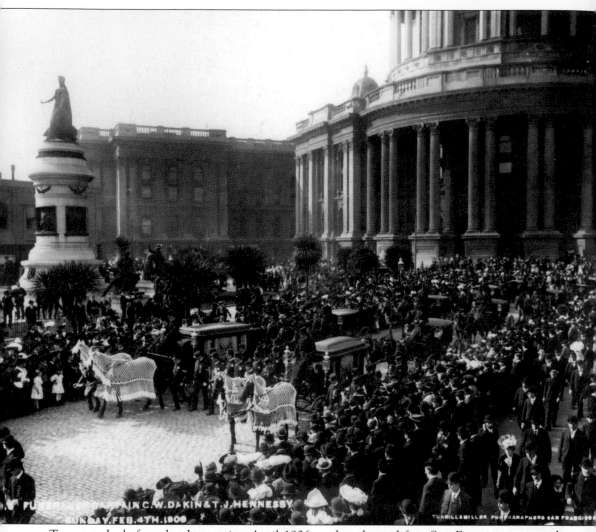

Two months before the devastating April 1906 earthquake and fire, San Francisco mourned SFFD firemen Captain Charles W. Dakin and Tim J. Hennessy. Both lost their lives in a blaze on January 31, 1906, and their passing marked the fifth double fatality on the same day since the first death was recorded in the department, that of fireman James Welsh in 1851. Note the new city hall in the background; it would be destroyed just two months later. (Courtesy San Francisco History Center, San Francisco Public Library.)

A plaque marks the memorial home of Chief Dennis T. Sullivan at 870 Bush Street, between Taylor and Mason Streets and just five blocks from Union Square. Sullivan was killed at age 54 during the great earthquake of 1906. After saving his wife from the fire, he fell through three floors in a sea of wreckage into the cellar below. He suffered a slight fracture, several broken ribs, a punctured lung, a badly lacerated right hip, and countless bruises and abrasions. But most dreadful were the injuries caused by the steam and scalding water emanating from the radiator, which sprayed him until and during his rescue. Sullivan's San Francisco firemen remained heroic though, continuing to battle for three long days and nights the flames that were consuming their city despite being leaderless. (Courtesy San Francisco History Center, San Francisco Public Library.)

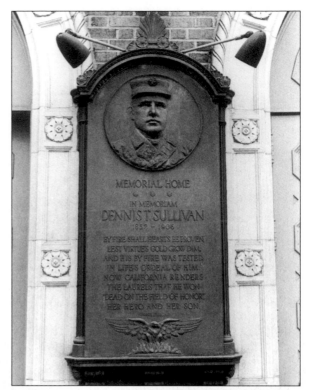

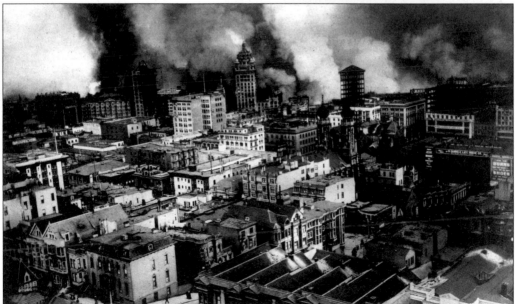

The destructive 1906 earthquake struck San Francisco at 5:12:05 on the morning of April 18, lasted for 48 seconds, and ignited a city-wide fire that would reach 2,700 degrees Fahrenheit. Approximately 28,000 buildings were destroyed in the inferno, covering an area of 4.11 square miles, or 497 blocks. It was estimated that $350 to $524 million worth of property (in 1906 dollars) was damaged. Approximately 3,000 deaths were documented, but the actual toll may have been upwards of 10,000. (Courtesy San Francisco History Center, San Francisco Public Library.)

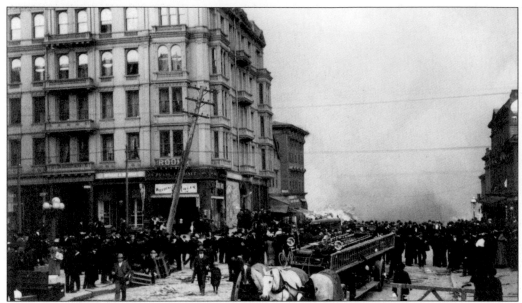

A large throng of citizens watch SFFD firefighters in action on Mission and Sixth Streets during the 1906 earthquake and fire. The quake hit San Francisco with a tremendous magnitude usually recorded as 7.9 on the Richter scale, but now as 8.25 according to a new version of measurement developed by Hiroo Kanamori, a well-respected seismologist at the California Institute of Technology. (Courtesy San Francisco History Center, San Francisco Public Library.)

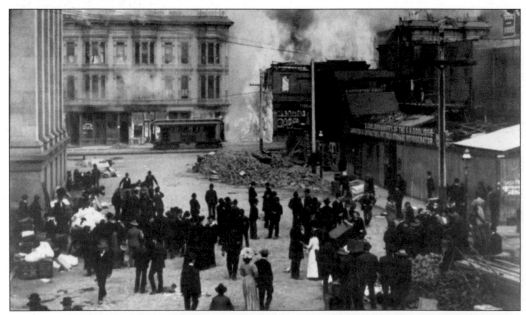

A huge crowd of people watch the roaring fire on Mission Street. The earthquake struck when two of the world's greatest tectonic plates, the Pacific and the North American, were unable to further withstand the geological tension and moved past each other a distance of 9 to 21 feet along the California coast. The break stretched nearly 290 miles from northern Mendocino County to southern Monterey County. (Courtesy San Francisco History Center, San Francisco Public Library.)

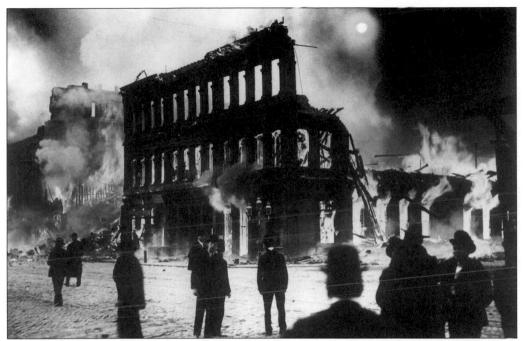

Intense fires burn bright on Market Street in the early morning hours of April 18, 1906. (Courtesy San Francisco History Center, San Francisco Public Library.)

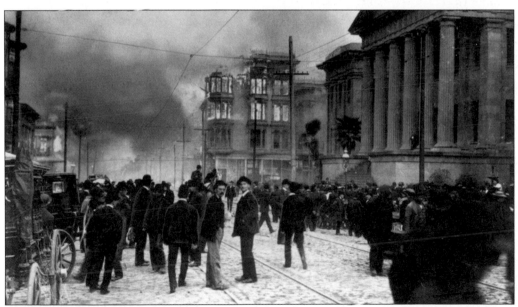

This is what the corner of Fifth and Mission Streets looked like on the morning of April 18, 1906. Mint workers climbed to the roof of "The Granite Lady" to protect it, while nearby a four-story tenement burned. Author Jack London had earlier lived in this property, and on this same devastating day, his birthplace at 615 Third Street was also destroyed. Note the horse-drawn hearses on the left; they were being used to evacuate people in poor health and to carry whatever belongings they had managed to grab. (Courtesy San Francisco History Center, San Francisco Public Library.)

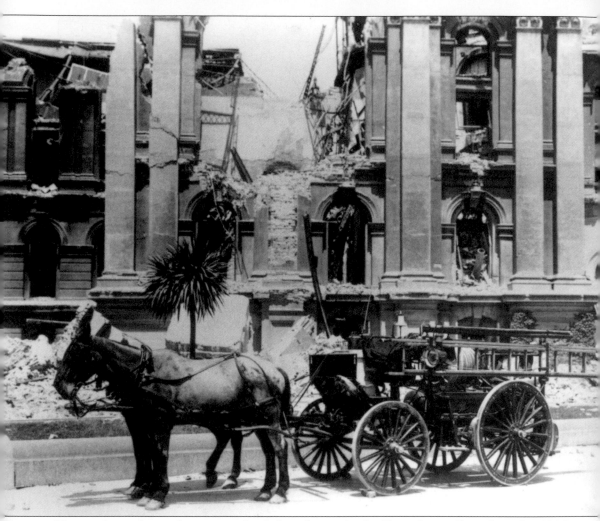

Here, a horse-drawn fire engine "parks" in front of a building that collapsed in the 1906 earthquake and fire. Earlier, in 1866, the state legislature passed a bill to reorganize the fire department in San Francisco. This bill provided for a paid fire department with modern steam fire engines that were to be horse drawn. This legislation became effective on December 3, 1866, and·on that day the old volunteer fire department, which had been in operation since 1849, ceased to exist. That historic bill marked the transition from the old hand-drawn apparatus to the horse drawn and steam powered engines. (Courtesy San Francisco History Center, San Francisco Public Library.)

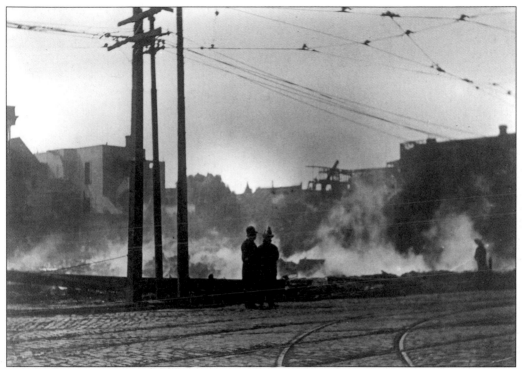

A policeman, wearing a distinctive bobbie-style hat, and a fireman stand together in front of the burning embers. Destruction and the stench of burning flesh pervaded the city. (Courtesy San Francisco History Center, San Francisco Public Library.)

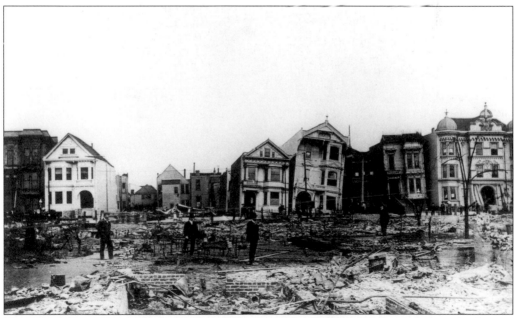

This image shows Howard Street between Seventeenth and Eighteenth Streets, where the fire was stopped at its southern perimeter. Note how the old three-story buildings were completely knocked off their foundations. (Courtesy San Francisco History Center, San Francisco Public Library.)

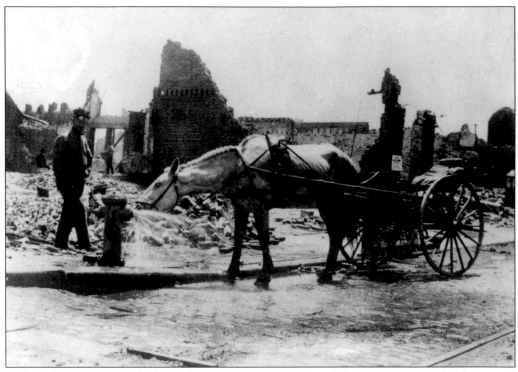

A horse drinks from a fire hydrant after the 1906 earthquake and fire once water was finally restored to all the hydrants. (Courtesy San Francisco History Center, San Francisco Public Library.)

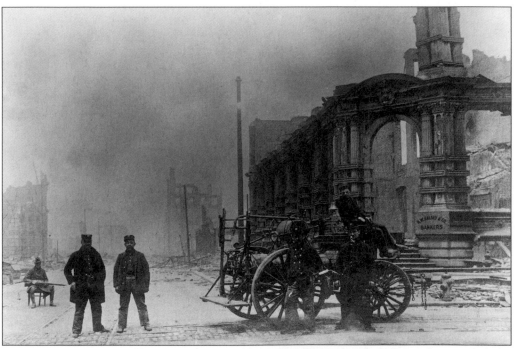

Here, some men pose with a fire engine in front of buildings that have been destroyed in the devastation of 1906. (Courtesy San Francisco History Center, San Francisco Public Library.)

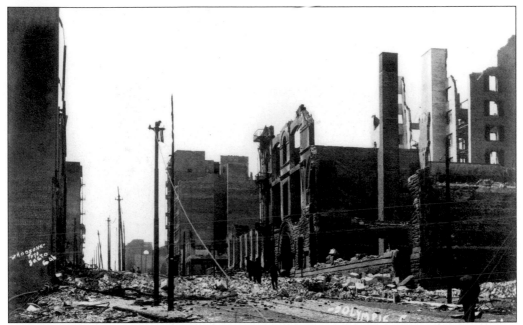

The ruins of the San Francisco Olympic Club on Post Street are pictured here. The Olympic Club, founded in 1860 and the oldest athletic club in the nation, was rebuilt. The club's initial location was at Lafayette Hook and Ladder Company on Broadway Street, between Stockton and Dupont (now Grant). Courtesy San Francisco History Center, San Francisco Public Library.)

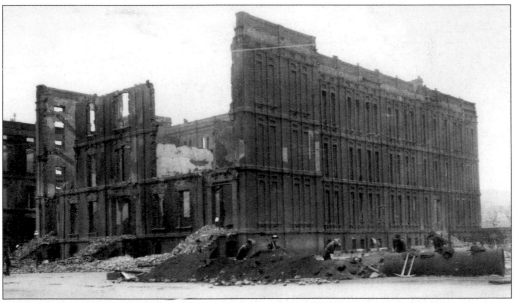

Saint Ignatius High School, which began operations in 1855, is pictured here in ruins at its location at Van Ness and Hayes Streets. Initially, the Jesuit-run school which educated several future SFFD fire fighters, was situated on the site of the old Emporium until 1879, then at the site seen here until 1906, then at the current home of the University of San Francisco until 1969, and now at 2001 Thirty-seventh Avenue, near the beach. (Courtesy San Francisco History Center, San Francisco Public Library.)

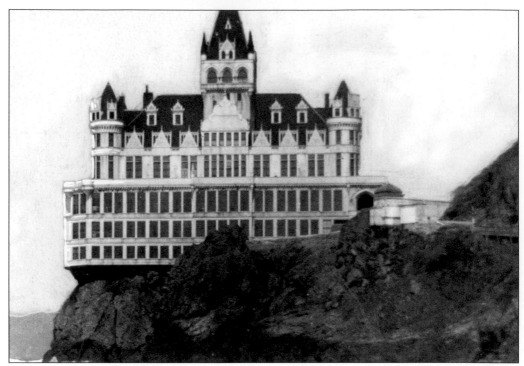

The majestic, seven-story Cliff House, seen here, was built in 1894 after the first Cliff House (1863–1894) was consumed by fire. This popular spot sits in on a rocky point overlooking Seal Rocks to the west and Ocean Beach to the south. (Courtesy San Francisco History Center, San Francisco Public Library.)

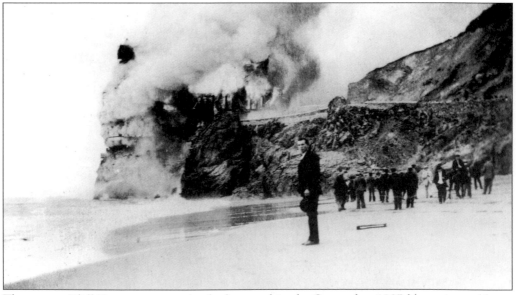

The ornate Cliff House was completely destroyed in the September 1907 blaze pictured here. The gentleman in the foreground is standing on the northern portion of Ocean Beach. A third Cliff House stands today on the same property and has undergone a major renovation. (Courtesy San Francisco History Center, San Francisco Public Library.)

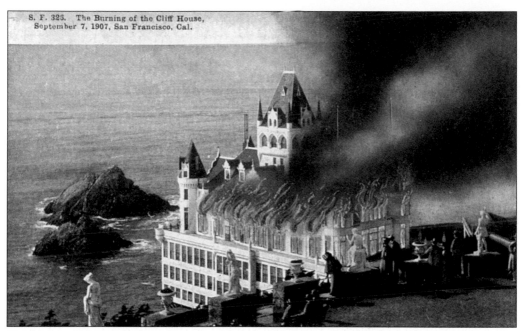

S. F. 323. The Burning of the Cliff House, September 7, 1907, San Francisco, Cal.

Gawkers on Adolf Sutro Mountain watch the firefighting operations to save the Cliff House as it burns in September 1907. (Courtesy author.)

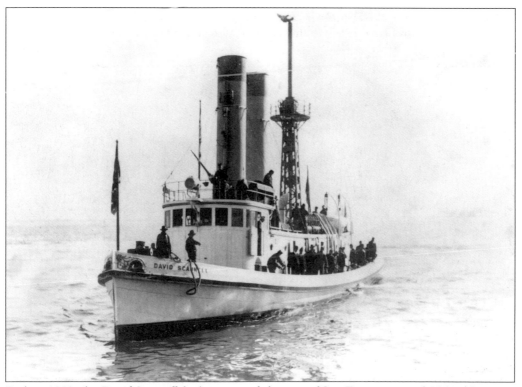

Built c. 1909, the *David Scannell* fireboat served the city of San Francisco until 1954. (Courtesy San Francisco History Center, San Francisco Public Library.)

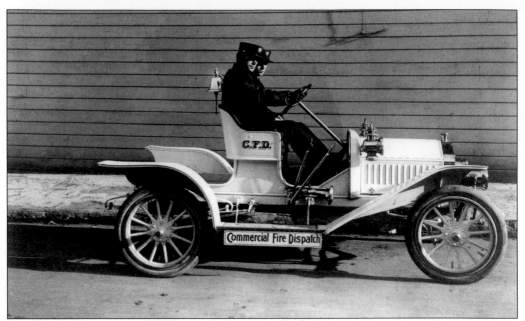

The group known as Commercial Fire Dispatch was responsible for many of the downtown buildings in the city. They held keys to most commercial buildings and would meet the SFFD at the scene of a fire. The group is now defunct, and all its remaining assets were auctioned off on eBay, including the property's contents and even the chief's sedan automobile. The old Commercial Fire Dispatch headquarters, established in 1887, was located at 229 Oak Street, between Gough and Octavia Streets, and is now a private residence. (Courtesy San Francisco History Center, San Francisco Public Library.)

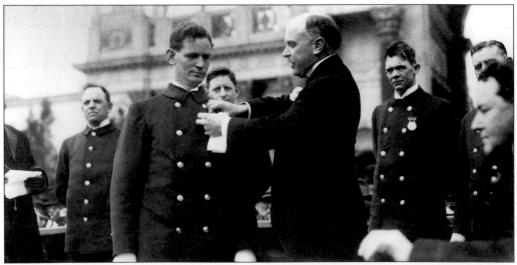

San Francisco mayor James Rolph proudly presents medals to firemen at the Panama-Pacific International Exposition in April 1915. The exposition's only extant structure, the Palace of Fine Arts in today's Marina district, had a special decorative alarm box made for the SFFD. This unique fire box is topped by a red light, and after the exposition, many were relocated for usage along the piers, the scenic waterfront, and Herb Caen Way. One is on display in the SFFD Museum. (Courtesy San Francisco History Center, San Francisco Public Library.)

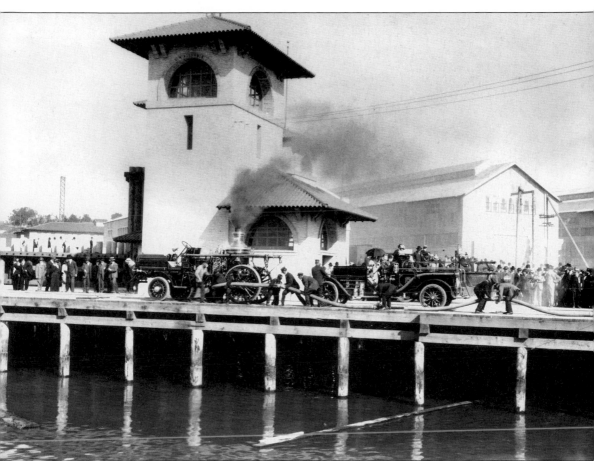

The SFFD tested equipment near the Panama-Pacific International Exposition in April 1915. To this day, San Francisco firefighters are unique in their use of wooden ladders, made of hickory and oak. While other cities now use metal ladders, the SFFD's use of wooden ladders reduces the risk of electrocution to firefighters working among so many power lines. (Courtesy San Francisco History Center, San Francisco Public Library.)

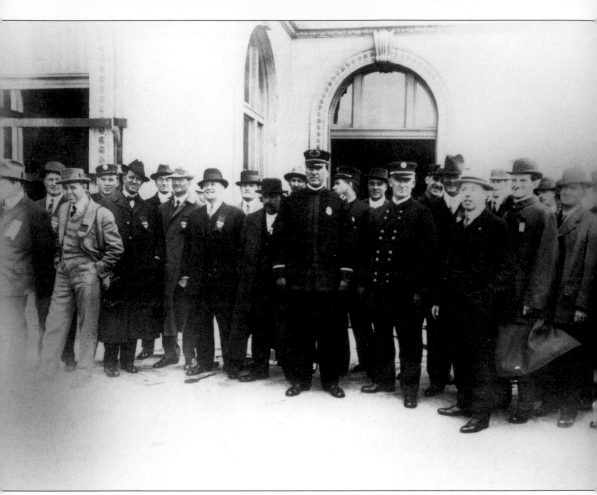

SFPD's Chief David Augustus White (left) and SFFD Chief Thomas R. Murphy (right) pose for this image as the SFFD tested equipment near the Panama-Pacific International Exposition in April 1915. (Courtesy San Francisco History Center, San Francisco Public Library.)

Chief Murphy of the SFFD stands next to a wall-mounted fire alarm at the Panama-Pacific International Exposition in April 1915. (Courtesy San Francisco History Center, San Francisco Public Library.)

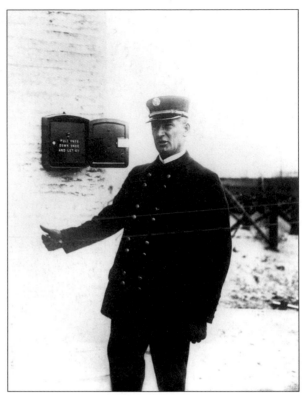

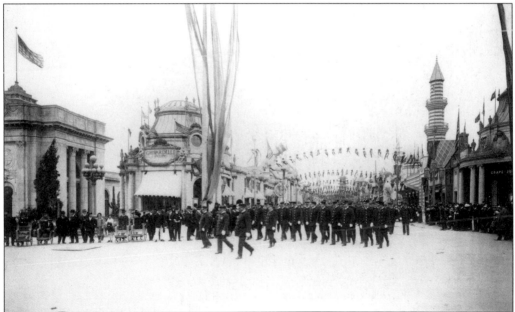

"The Nine Years After" parade at the 1915 Panama-Pacific International Exposition was led by Chief Thomas R. Murphy. Still in the process of rebuilding nine years after the 1906 earthquake and fire, San Francisco had begun to construct many firehouses on hills—they became known as "hill companies"—because it was reasoned that, in an emergency, it was easier to go downhill than uphill. (Courtesy San Francisco History Center, San Francisco Public Library.)

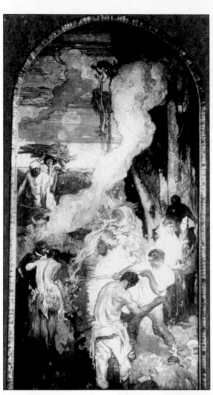

This mural entitled *Fire* was created for the Panama-Pacific International Exposition held in San Francisco in April 1915. (Courtesy San Francisco History Center, San Francisco Public Library.)

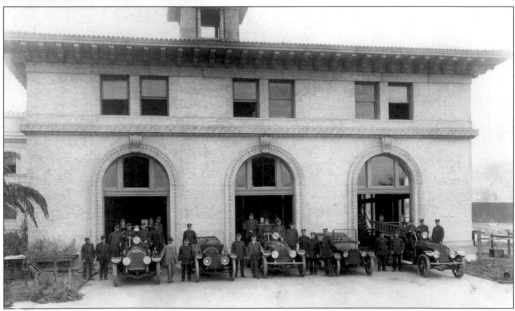

Here, SFFD firemen pose at the Panama-Pacific International Exposition. According to an August 1991 interview with Bill Maloney (SFFD, 1947–1977), following the 1906 earthquake, several members of the fire department rolled back their ages, as all birth certificates were lost, so that they could remain in the SFFD longer than was permitted. In another interview, Chief William Murray (SFFD 1920–1970) related that men during this period were not allowed to be married when they entered the SFFD. (Courtesy San Francisco History Center, San Francisco Public Library.)

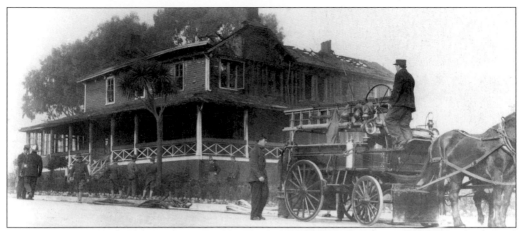

This fatal fire at the home of Gen. John "Blackjack" Pershing in August 1915 killed his wife and three daughters; however, his son Warren survived when the general's African-American orderly, at great personal risk, saved the child. The victims suffocated in the early morning fire when coal in an unattended fireplace fell to the highly waxed floor of the wooden house. After the fire, the general's father-in-law, Wyoming senator Francis E. Warren, used his influence, bolstered by the strong recommendation of SFFD Chief Thomas Murphy, to have the U.S. Army build a fire station in the Presidio in 1917. The location paid off in 1989 when the Presidio Fire Department's Engine 2 was the first on the scene at the Marina district fire, following the Loma Prieta earthquake. (Courtesy San Francisco History Center, San Francisco Public Library.)

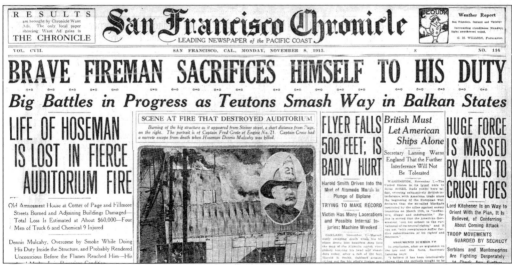

The death of Engine 21 hoseman Dennis Mulcahy made the front page of the November 8, 1915 edition of the *San Francisco Chronicle*. Mulcahy died the day before in an old auditorium fire at Page and Fillmore Streets. He was trapped by flames and his body was completely burnt. His 80-year-old widowed mother, Julia Mulcahy, refused to believe the news of his death when she was told of it, at least until that night when he did not come home. Page two of the paper reported that "when his charred remains were carried out of the smoldering ruin by deputies from the Coroner's office they were surrounded by a crowd of spectators, who with a single impulse uncovered, and stood with heads bowed while the sad procession passed. Several big, fearless firefighters, comrades of the dead man, broke down and sobbed audibly, while others wiped away a hot tear with a grimy hand." (Courtesy author.)

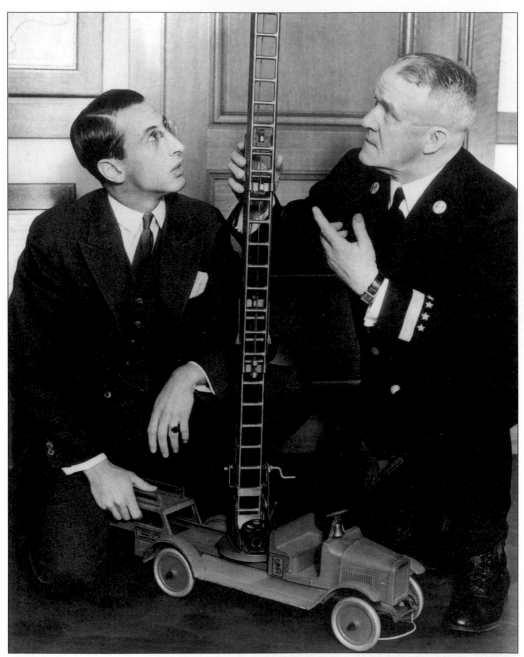

In this March 1931 image, Chief Charles F. Brennan and Robert Levison, the chairman of the San Francisco Junior Chamber of Commerce (SFJCC) Fire Prevention Committee, use a children's toy to discuss a very real proposed aerial ladder for the SFFD. (Courtesy San Francisco History Center, San Francisco Public Library.)

This photograph shows a superimposed composite of Miss Verona Dahl of the SFJCC and Capt. Theodore Trivett of the SFFD with the Ferry Building. The tower, modeled after one in Spain, was labeled a grave fire hazard to the city by the SFJCC during its Harbor Day campaign in August 1930. (Courtesy San Francisco History Center, San Francisco Public Library.)

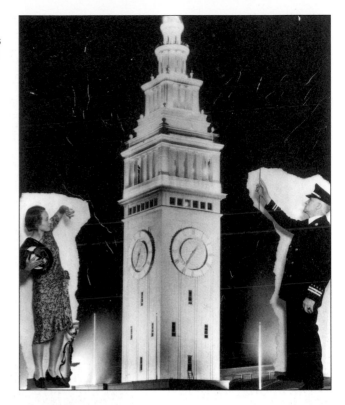

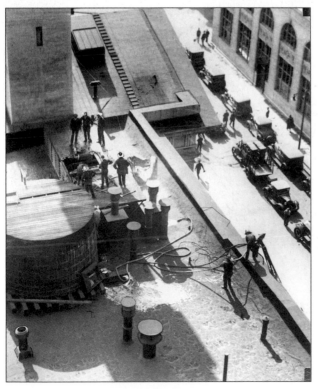

In October 1931 firefighters worked on the rooftop of the Old Mint to extinguish a fire. The building was in operation as a mint from 1874 until 1937. (Courtesy San Francisco History Center, San Francisco Public Library.)

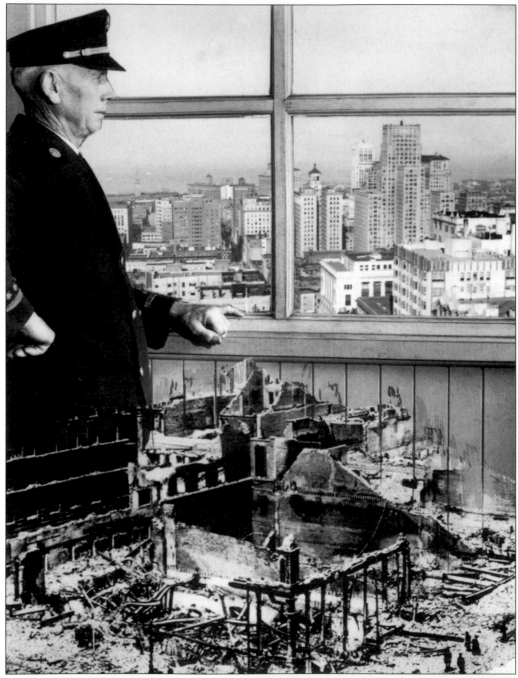

This 1931 photograph shows Battalion Chief Edward J. Skelly looking out a window at the city skyline while standing next to a model of what the same area looked like just 25 years prior. (Courtesy San Francisco History Center, San Francisco Public Library.)

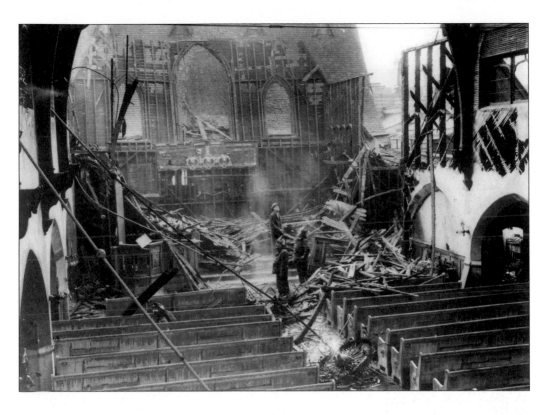

These photographs illustrate the February 1933 fire at Reverend Kelly's church, St. John the Evangelist. (Courtesy San Francisco History Center, San Francisco Public Library.)

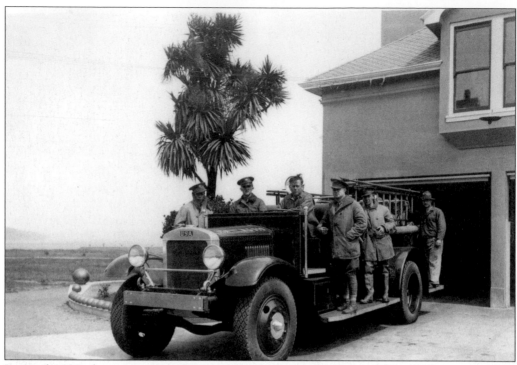

In April 1933, the men at Presidio Fire Station, serving under Sgt. W.M. Williams, posed for this photograph. (Courtesy San Francisco History Center, San Francisco Public Library.)

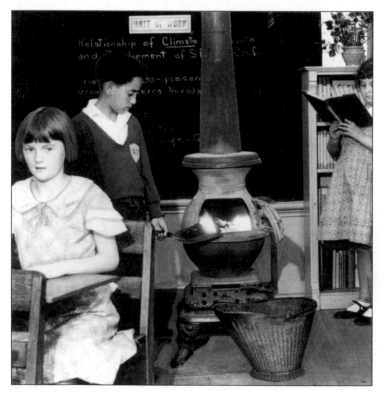

Students at Buena Vista School were responsible for shoveling coal into the classroom stove, pictured here in April 1933, which created a potential fire hazard. (Courtesy San Francisco History Center, San Francisco Public Library.)

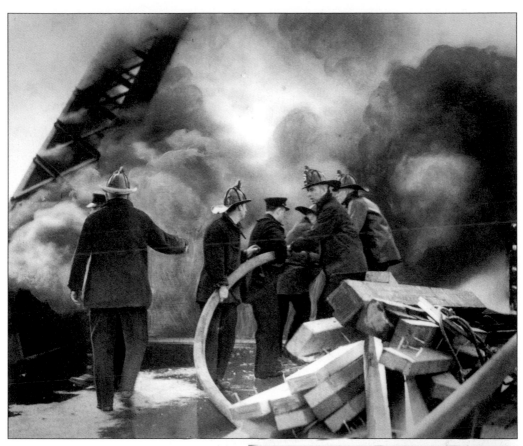

The Third Street Bridge, engulfed in flames in April 1933, has a companion bridge on Fourth Street known as the Peter R. Maloney Bridge. These bascule bridges were designed by Joseph Strauss, who designed over 400 other bridges, though he is perhaps best known for San Francisco's Golden Gate Bridge. The SFFD has fought fires on all of its major bridges since its inception. (Courtesy San Francisco History Center, San Francisco Public Library.)

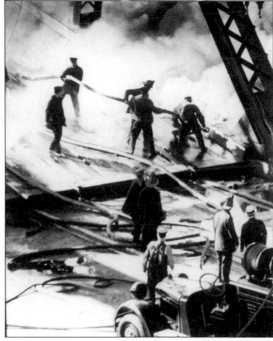

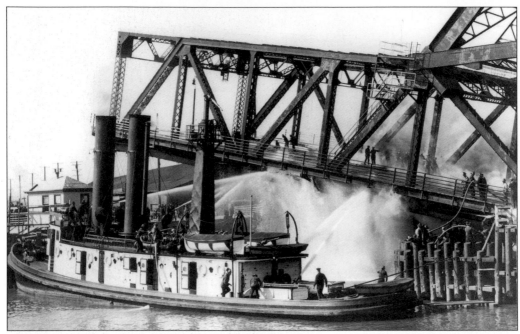

The SFFD fireboat at Mission Creek and firefighters extinguish a fire in April 1933 at the Third Street Bridge. This drawbridge, now called the Lefty O'Doul Bridge, is adjacent to the San Francisco Giants' Pac Bell Park. (Courtesy San Francisco History Center, San Francisco Public Library.)

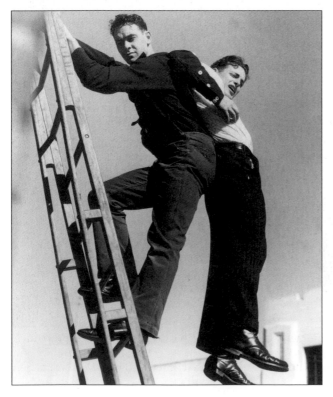

In this November 1933 scene, fireman John Regan transports fellow fireman Herbert Cabeceira in a famous "shirt carry," which was used to rescue individuals from the upper stories of burning buildings. (Courtesy San Francisco History Center, San Francisco Public Library.)

Sculptor Haig Patigian is pictured with the bronze statue he created to commemorate San Francisco's volunteer fire department of 1849–1866. The piece was erected in Washington Square in 1933 and paid for by the bequest of Lillie Hitchcock Coit. (Courtesy San Francisco History Center, San Francisco Public Library.)

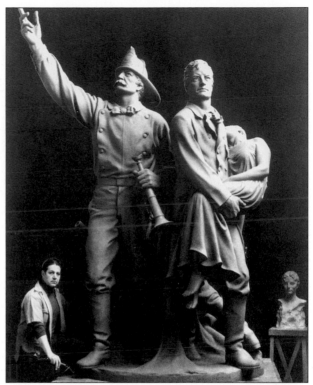

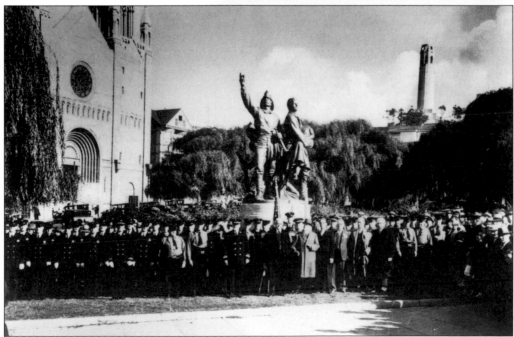

The memorial was dedicated in a ceremony held in December 1933. The square in which the statue sits was once a true square, that is until Columbus Avenue was constructed and cut off a portion of the southwest corner. (Courtesy San Francisco History Center, San Francisco Public Library.)

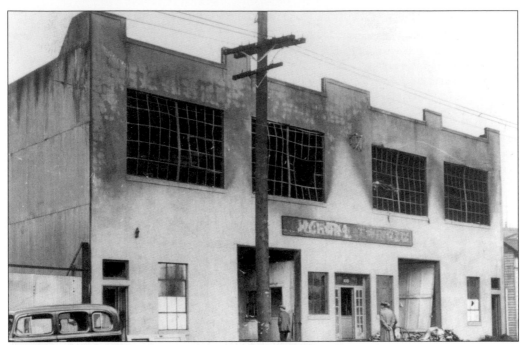

The exterior of the Anchor Brewing Company, which has been making steam beer since 1898, is seen here after the February 1934 fire that destroyed the building. (Courtesy San Francisco History Center, San Francisco Public Library.)

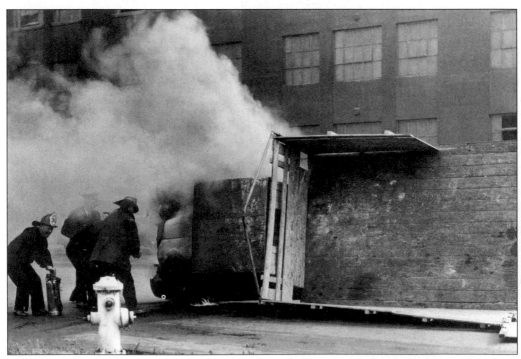

SFFD firemen extinguish a truck fire during the Longshoreman strike along the San Francisco waterfront in July 1934. (Courtesy San Francisco History Center, San Francisco Public Library.)

SFFD Chief Charles F. Brennan, wearing a three-piece suit and a ceremonial head dress, is pictured with Native Americans Chief Big Smoke (to his right) and Rising Buffalo (on his left with the drum) in September 1934. (Courtesy San Francisco History Center, San Francisco Public Library.)

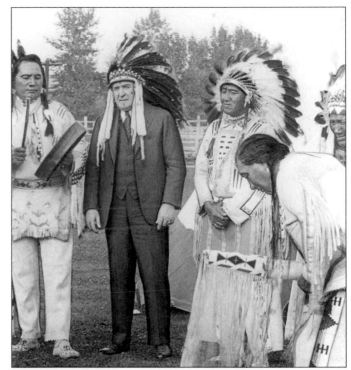

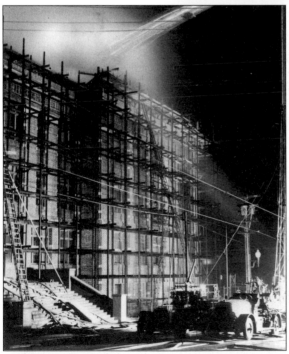

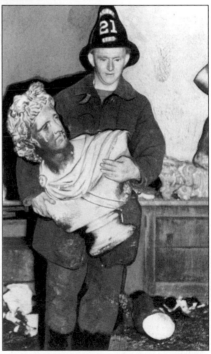

SFFD firemen use this water tower, in the image on the left, to pour thousands of gallons of water on Lowell High School during the fire in November 1934. On the right, SFFD fireman El Aitkeb, with Engine 21, carries a bust of Apollo from Lowell High School in order to save it from further damage. (Both courtesy San Francisco History Center, San Francisco Public Library.)

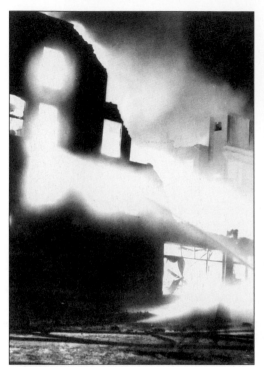
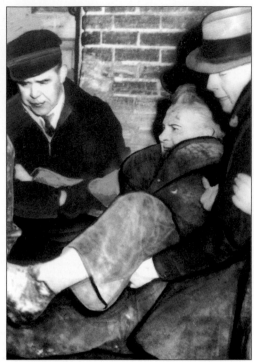

SFFD firemen bravely fight the December 1934 Victoria Hotel fire and rescue victims from the blaze. (Both courtesy San Francisco History Center, San Francisco Public Library.)

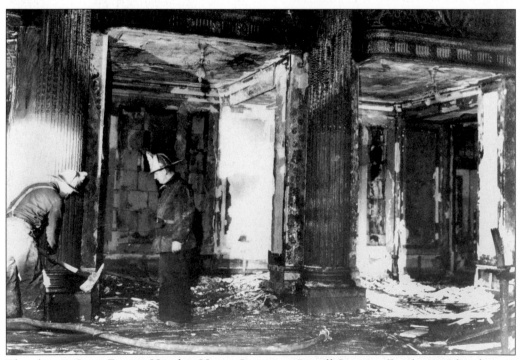

The elegant Saint Francis Hotel at Union Square on Powell Street suffered major fire damage in this 1934 blaze. (Courtesy San Francisco History Center, San Francisco Public Library.)

A firefighter wears the famous asbestos suit for this March 1935 photograph. The suit was used in rescue operations. (Courtesy San Francisco History Center, San Francisco Public Library.)

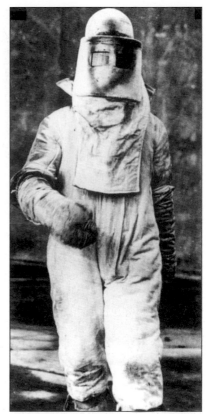

Firefighters show us the definition of teamwork while fighting a fire at Pier 44 and prying up pavement to get access to it in June 1935. This photograph might remind readers of the famous U.S. Marine Corps photograph by Joe Rosenthal taken on Iwo Jima's Mount Suribachi during World War II. (Courtesy San Francisco History Center, San Francisco Public Library.)

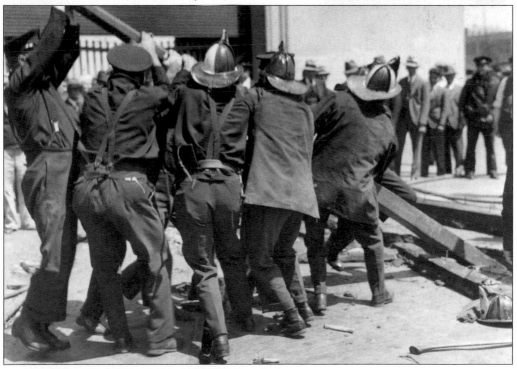

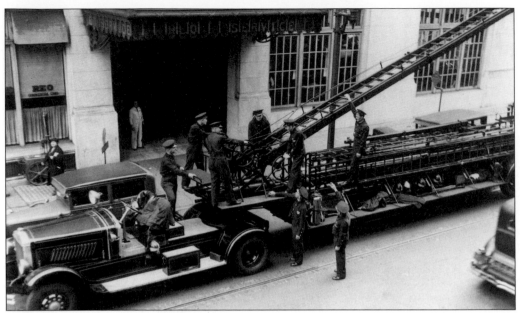

Engine 3, an old-style aerial ladder, is pictured here in August 1935. (Courtesy San Francisco History Center, San Francisco Public Library.)

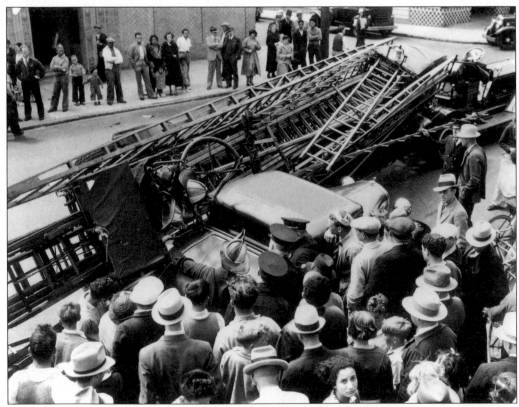

Oops! This hook and ladder crashed in July 1935. (Courtesy San Francisco History Center, San Francisco Public Library.)

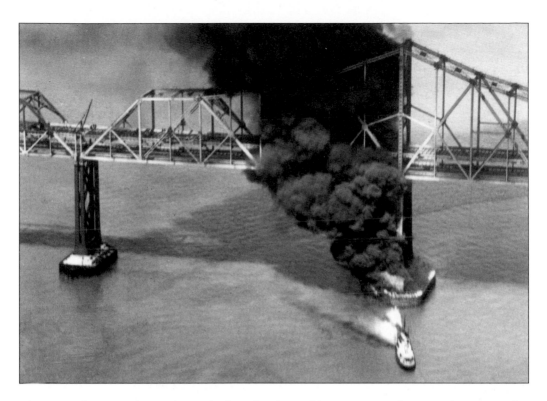

These aerial images show a SFFD fireboat battling a blaze on a cantilever on the Bay Bridge between San Francisco and Oakland in April 1936. (Courtesy San Francisco History Center, San Francisco Public Library.)

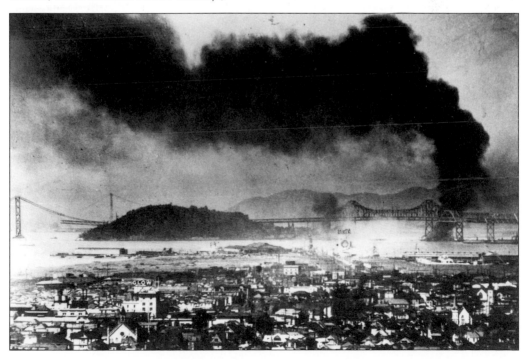

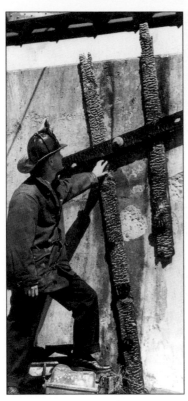

In April 1936, a fireman inspects the remains of a ladder that was burned in the fire on the Bay Bridge. (Courtesy San Francisco History Center, San Francisco Public Library.)

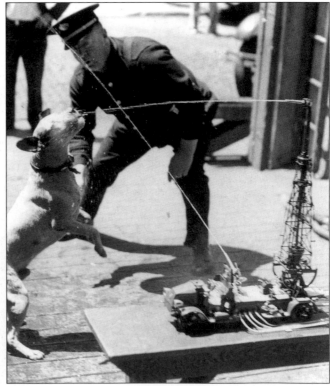

Jiggs the dog, seen here in a May 1936 photograph, was the mascot of Engine #3 and Truck #3. He is playing with a toy water tower and SFFD Captain William Vandervort. (Courtesy San Francisco History Center, San Francisco Public Library.)

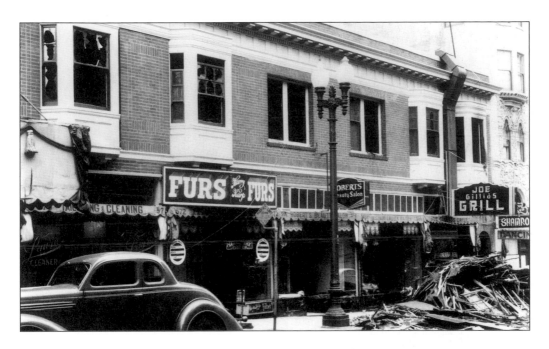

These May 1936 images help tell the story of the fire at the Shamrock nightclub, located at 560 Geary Street, that resulted in the deaths of four people. Photos show the exterior of the building after the fire and Coroner T.B.W. Leland's (holding lantern) subsequent inquest jury. They were looking for evidence that arson may have been responsible since chemical findings suggested the ceiling cloth hangings were possibly soaked in kerosene. The fire began when dancer Betty Blossom's torch ignited the draperies. (Courtesy San Francisco History Center, San Francisco Public Library.)

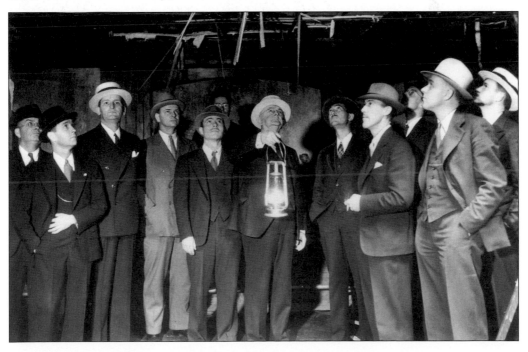

Firemen put out a garage fire at Laguna Honda Home in April 1936 in an incident involving the explosion of a drum of gasoline that injured three people. Three cars and one truck were also destroyed. All available emergency ambulances were dispatched to the scene to render assistance. (Courtesy San Francisco History Center, San Francisco Public Library.)

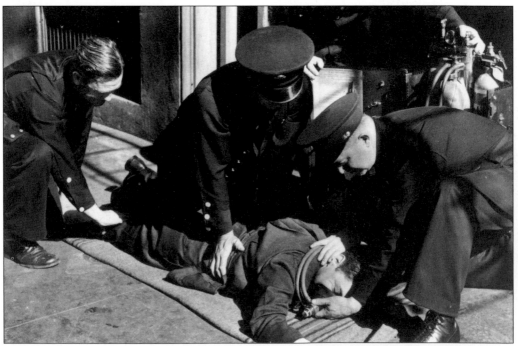

The old-fashioned, kidney-method of artificial respiration is demonstrated by fireman Richard Diaz in October 1937. This method is no longer used today. (Courtesy San Francisco History Center, San Francisco Public Library.)

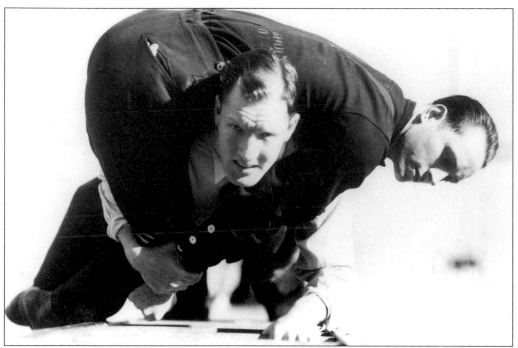

These unknown firemen demonstrate a shoulder carry in this October 1937 image. (Courtesy San Francisco History Center, San Francisco Public Library.)

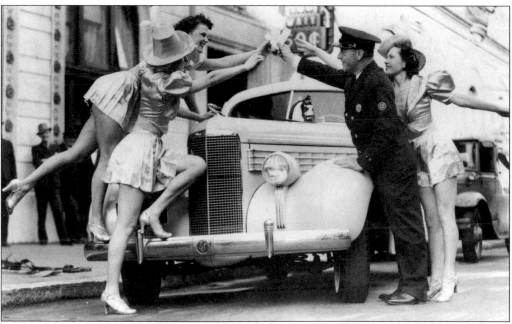

The November 1937 Fireman's Ball at Civic Auditorium, now known as the Bill Graham Memorial Auditorium, featured three attractive ballerinas and a 1938 La Salle Sedan giveaway. Pictured here from left to right, are Fern Guymon, Madeline Thomas, fireman Dan Sullivan from the Rescue Squad, and Eudene Saunders. This event is now known as the Hook and Ladder Ball. (Courtesy San Francisco History Center, San Francisco Public Library.)

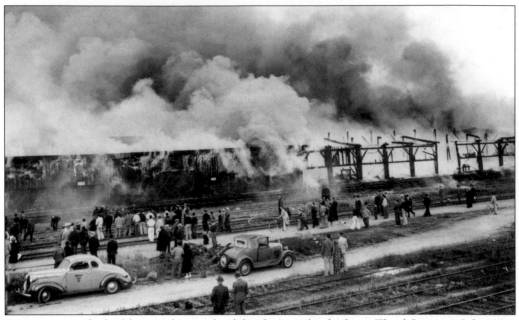

Spectators watch the blaze at the overland freight transfer sheds on Third Street in July 1938. (Courtesy San Francisco History Center, San Francisco Public Library.)

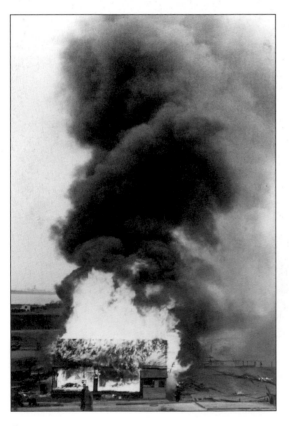

In April 1939, SFFD firemen torched the 70-year-old Shrimp Camp at Hunters Point. (Courtesy San Francisco History Center, San Francisco Public Library.)

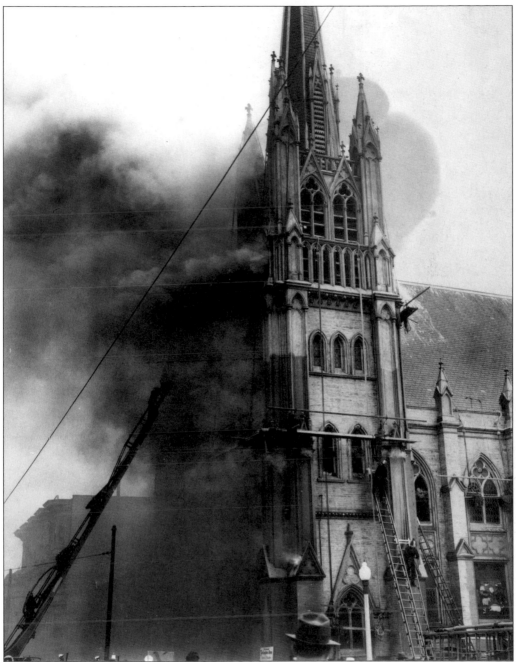

SFFD firefighters answer prayers by arriving to fight this June 1940 fire at St. Paulus Church. The four-alarm fire swept through the edifice at Gough and Eddy Streets. Four firemen were hurt in the conflagration, but structural damage was minimal. (Courtesy San Francisco History Center, San Francisco Public Library.)

The Bell Tower in Golden Gate Park is pictured here on fire in June 1939. Note the brave man in the lower right corner in a suit and tie trying to contain the fire. (Courtesy San Francisco History Center, San Francisco Public Library.)

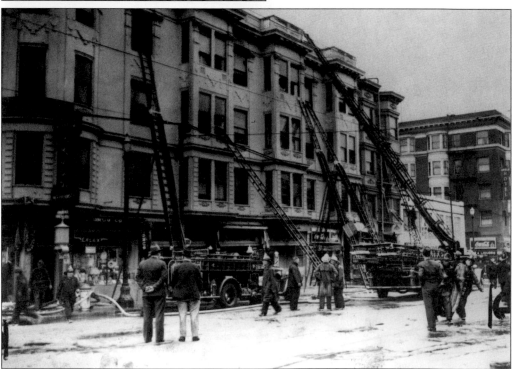

In July 1940 SFFD firefighters attack a blaze at the Argonne Hotel that gutted the building's interior and killed two people. Heroic rescue work was carried out by these SFFD firemen. (Courtesy San Francisco History Center, San Francisco Public Library.)

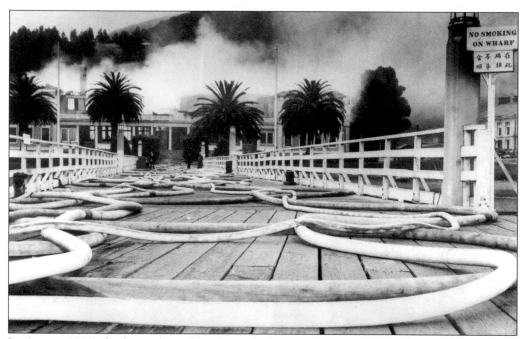

In August 1940, the hoses from the SFFD's fireboat *Dennis T. Sullivan* look like spaghetti on the wharf area on the northern cove of Angel island. (Courtesy San Francisco History Center, San Francisco Public Library.)

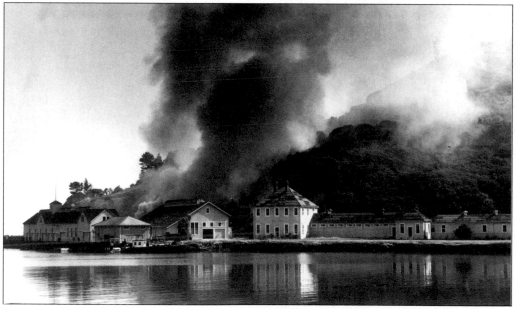

In August 1940, a fire on Angel Island was intentionally set in order to destroy buildings during demolition. A total of 24 buildings were demolished so the area could become a state park. This destruction of history is now part of an area known as the Ellis Island of the West, as it was the site of significant Asian immigration to the West Coast of the United States. Fortunately, some of the significant historical buildings were spared and some even contain poems and graffiti written by immigrants. (Courtesy San Francisco History Center, San Francisco Public Library.)

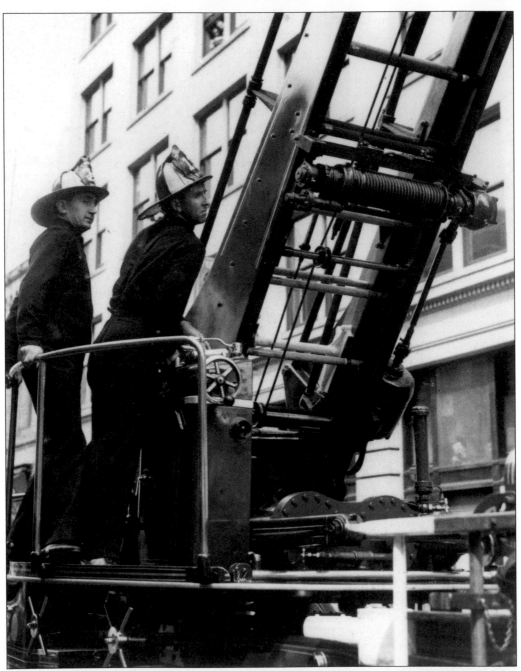

This April 1941 photograph shows the turntable on fire truck #13, as well as, from left to right, firemen Donald Cummings and Andy Casper, a future SFFD chief. This ladder was fully controlled from the turntable mounted on the base of the fire truck and operated when an electrical motor raised the aerial ladder skyward. This technology allowed rescues from the upper floors of buildings engulfed in flames. The ladder could be stretched in telescopic fashion to the desired height and also revolved a complete 360 degrees. Before these aerial trucks, a 65-foot aerial ladder was used by the SFFD for rescue operations. (Courtesy San Francisco History Center, San Francisco Public Library.)

In October 1940, fireman John Flanagan attempted to shut off a broken water hydrant on Minna Street with a "T" wrench. The extreme force of this geyser-like spray had already knocked one firefighter down, as evidenced by his helmet floating on the water. (Courtesy San Francisco History Center, San Francisco Public Library.)

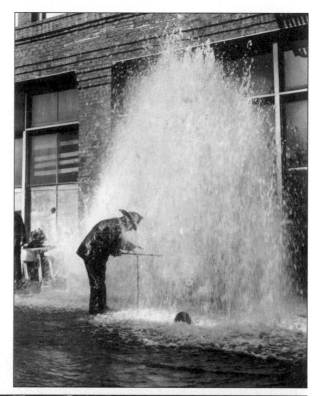

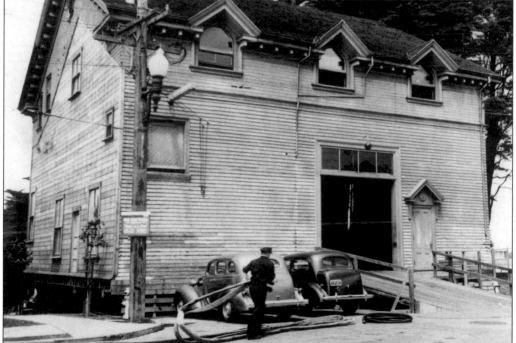

A fireman, identified only as "Mr. Fixit" on the back of this photograph, is pictured in front of old engine 32 in 1940. This firehouse is at Appleton and Elsie Streets. (Courtesy San Francisco History Center, San Francisco Public Library.)

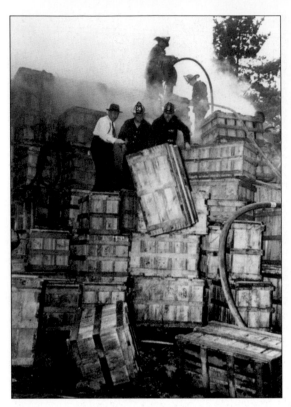

In Golden Gate Park on September 1941, SFFD firemen put out a fire behind the DeYoung Museum that threatened the famed 13th-century Cistercian Spanish monastery of Santa Maria de Ovila that was once owned by William Randolph Hearst. The structure was to have been re-assembled by famed architect Julia Morgan before the Depression hit. There are now plans to preserve what remains of the monastery, following the 1991 donation of the remaining stones by the city of San Francisco to the Cistercian Abbey of New Clairvaux in Vina, California. (Courtesy San Francisco History Center, San Francisco Public Library.)

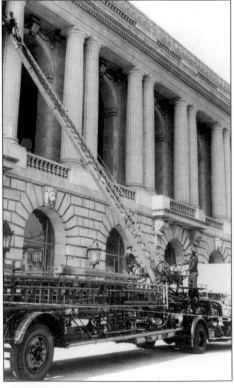

Little did these firemen realize when they signed up that they would be put to work cleaning the outside of the War Memorial Veterans Building on Van Ness Avenue. Pictured, from left to right, on the truck are W.E. Rafferty, Pete Molloy (top of ladder), and Al Alcayaga. (Courtesy San Francisco History Center, San Francisco Public Library.)

In October 1941, John Lawrence
Evans was rescued by the SFFD and
the San Francisco Police Department
(SFPD) after his suicide attempt on
the Golden Gate Bridge. Nearly 2,000
people have jumped from this span
since the bridge opened in 1937.
Interestingly, most jump toward the
city on the east side and not towards
the open ocean on the west side of the
span. (Courtesy San Francisco History
Center, San Francisco Public Library.)

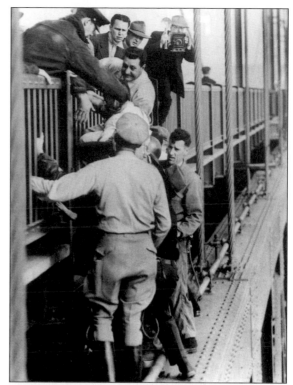

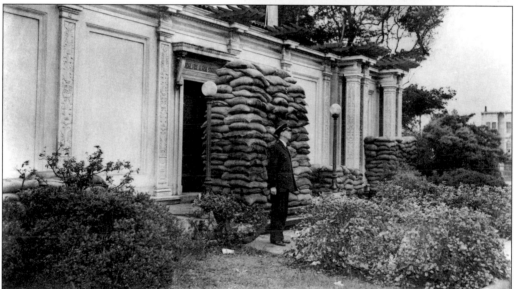

Pictured here is the Central Fire Alarm Station at Jefferson Square in late December 1941, just
weeks after the attack on Pearl Harbor. Mayor Angelo Rossie asked that the building be guarded
by federal troops, and sandbags were used to protect it from anticipated air raids that never came.
Today, air raid sirens still blare throughout the city every Tuesday at noon for the weekly test.
This building served San Francisco during the October 1989 earthquake but has since been razed
to make way for the new modern Emergency Communications Department on the 900 block of
Turk Street. (Courtesy San Francisco History Center, San Francisco Public Library.)

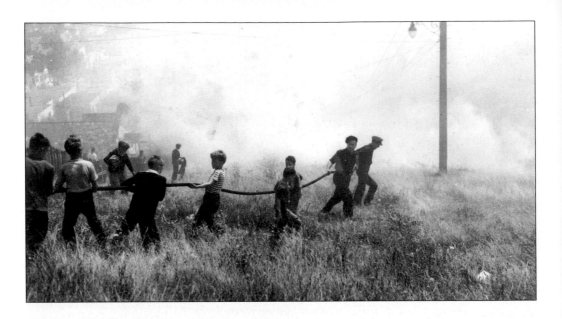

During World War II, Chief Albert J. Sullivan sent fire crews out almost daily to burn off lots and hills. These two June 1943 photographs show that some children got to live out their dreams by helping beat out this grassfire and drag one-inch hose line from Water Wagon #7 with real firemen! (Courtesy San Francisco History Center, San Francisco Public Library.)

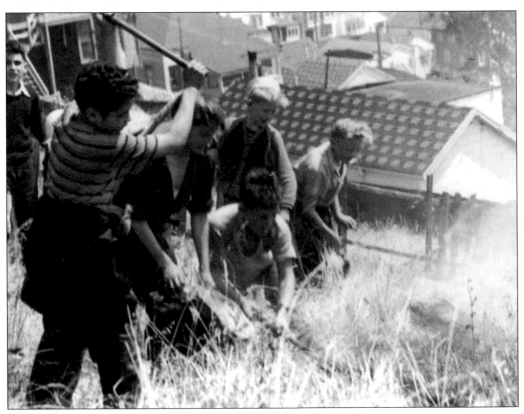

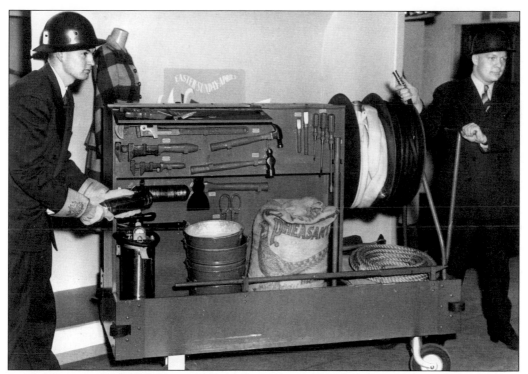

In March 1942, the Emporium, a major shopping center between Fourth and Fifth on Market Street, had a special fire equipment truck in case of an enemy air attack. (Courtesy San Francisco History Center, San Francisco Public Library.)

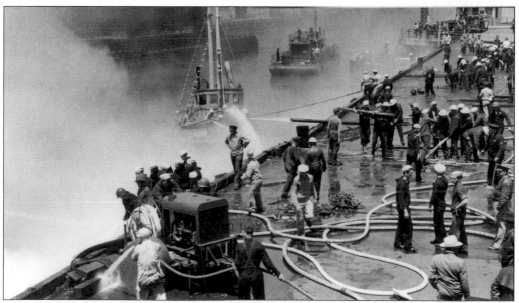

In February 1944, a fire at the waterfront brought out three pieces of Coast Guard equipment: an auxiliary pumper, the fireboat, and a fire barge. This equipment protected millions of dollars worth of war equipment that was awaiting shipment to U.S. military forces in the Pacific during World War II. (Courtesy San Francisco History Center, San Francisco Public Library.)

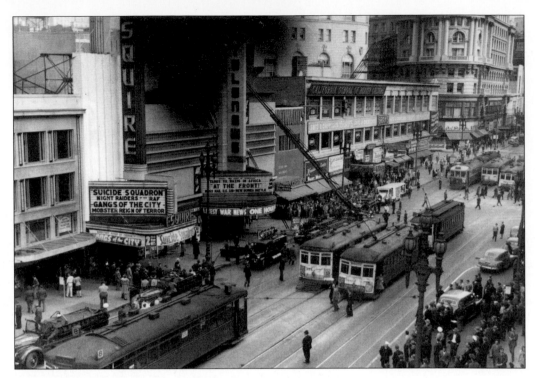

During the fire at the Telenews Theatre at 928 Market Street in March 1943, smoke from film and equipment burning in a projection booth produced a black cloud in front of the theatre that stopped traffic and brought massive crowds out. One man was hurt and 30 fled the theatre. (Both courtesy San Francisco History Center, San Francisco Public Library.)

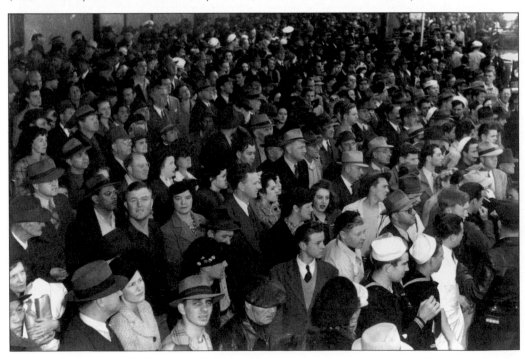

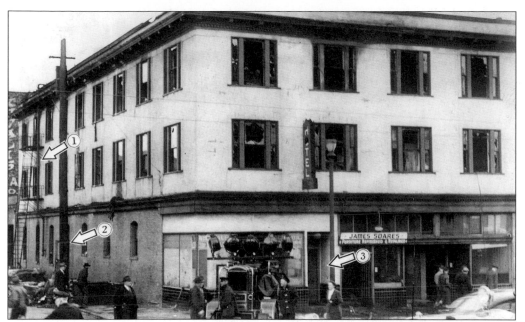

The disastrous fire at the New Amsterdam Hotel at Fourth and Clementina Streets occurred in March 1944. The blaze killed 22 people, and 27 more were injured. Bodies lined the sidewalks as Father Leo Powleson performed the last rites. Mrs. Minnie Pulsoki, the daughter of the hotel operator, jumped to her death, while guest Mr. Leslie McKinney, trapped in his room by flames, leapt from a third-story window and smacked into a wooden telephone pole that saved his life. The newspaper which carried this photo marked the three available exits: (1) the fire escape, (2) the door behind the pole on the left, and (3) the main door. The flash fire was started by a pyromaniac, and it gutted this property. (Courtesy San Francisco History Center, San Francisco Public Library.)

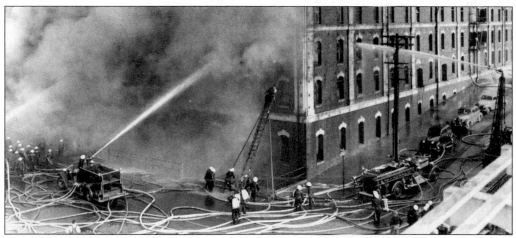

Pictured here is the 1944 Cannery fire at 680 Beach Street in Fisherman's Wharf, adjacent to Aquatic Park. History repeated itself on Saint Patrick's Day morning in 2002 as the Cannery building, which was undergoing renovations to turn it into a luxury hotel called the Argonaut, had a five-alarm blaze that sent 52 SFFD companies to the scene. The c. 1907 building was saved and is now an operational hotel. The Cannery, also called the Haslettt Warehouse, is a four-story brick building that was originally used for canning storage between 1907 and 1936. (Courtesy San Francisco History Center, San Francisco Public Library.)

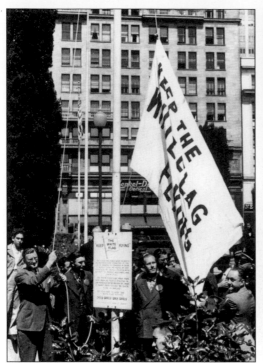 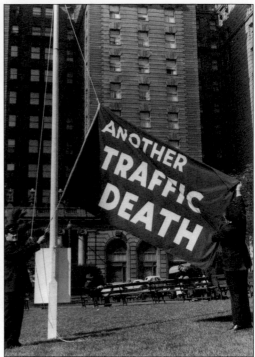

Safety symbols are raised at Union Square. The white flag symbolized that San Francisco went for a 24-hour period without a traffic death. It was taken down anytime there was a fatal traffic accident, and a black flag would be raised. Shown above are a white flag in 1944 with the words "Keep the White Flag Flying" and a black flag in 1936 with the words "Another Traffic Death." In the modern view of an accident site below, an anonymous person has spray-painted the outline of a body, the date, and the cause of death. (Above photo courtesy San Francisco History Center, San Francisco Public Library; below, courtesy author.)

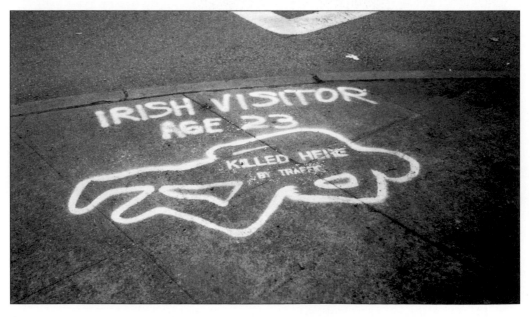

An April 1945 fire guts an auto parts building at 555 Golden Gate Avenue. Auxiliary fireman Sylvain Kay was injured, but he refused hospital treatment. (Courtesy San Francisco History Center, San Francisco Public Library.)

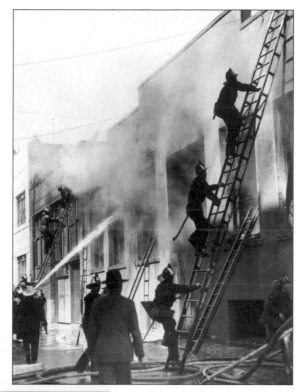

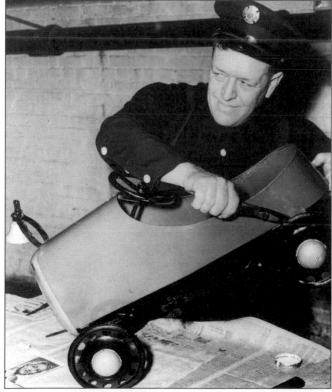

This June 1945 photograph shows fireman Robert Scheider fixing up a car with a bell to give to the city's youth during the next holiday season. Between 1948 and 1950, SFFD firehouses spared no expense in making the exterior of each structure a winter wonderland. Unfortunately, in 1950, SFFD top brass thought this competition between the houses was excessive and put a stop to the practice. (Courtesy San Francisco History Center, San Francisco Public Library.)

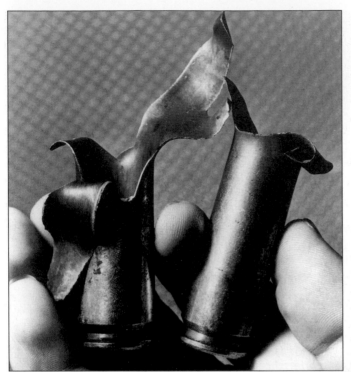

Ammunition like this added to the hazards faced by SFFD firefighters in this May 1946 fire near the Islais Creek, U.S. Marine Corps Ordnance Depot in the Bayshore District. Luckily there were no casualties. These jagged, 50-caliber shell cases exploded just one block away from the scene of the Ordnance Depot fire. Tremendous heat caused the explosion of thousands of rounds of military-grade ammunition. (Courtesy San Francisco History Center, San Francisco Public Library.)

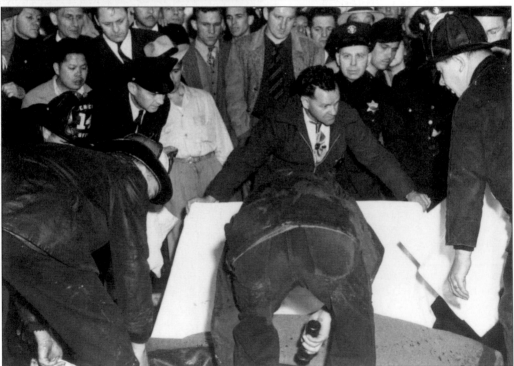

A sheet covers the body of Lt. John M. Borman on 161 Powell Street after the 1946 Hotel Herbert fire. Note the incredible expressions on the faces of spectators who witnessed such bravery in the line of duty. (Courtesy San Francisco History Center, San Francisco Public Library.)

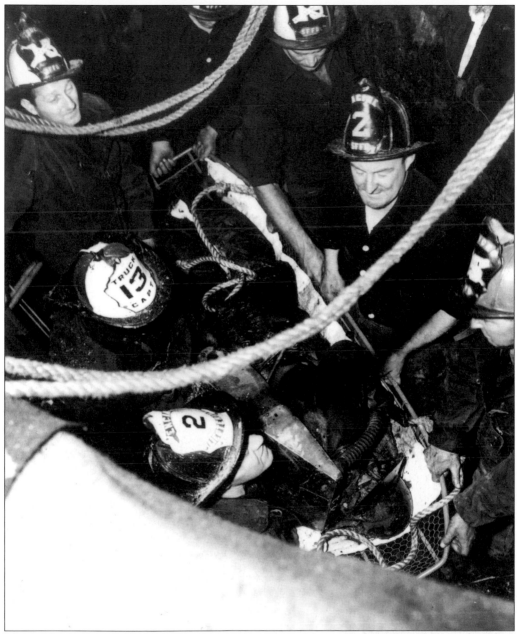

The lifeless body of fireman Walter Elvitsky is removed from the basement in the 1946 Hotel Herbert fire. Note that the helmet and oxygen tank are still on this hero's body. (Courtesy San Francisco History Center, San Francisco Public Library.)

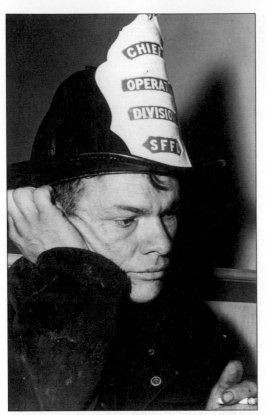

Dazed by extreme grief and total exhaustion, fireman E.J. Russell (with cigarette) sits on the curb near the smoldering wreckage outside the Hotel Herbert at 161 Powell Street. He said, as he cried, "My best buddies, my best pals, I saw them die." (Courtesy San Francisco History Center, San Francisco Public Library.)

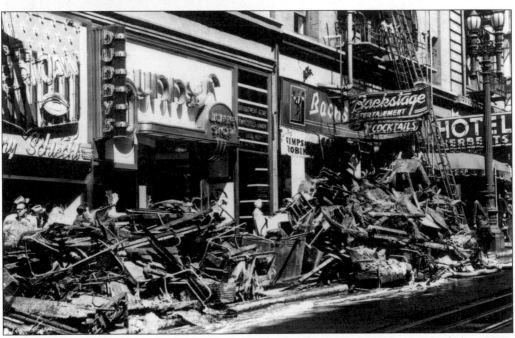

Outside the Hotel Herbert, the debris is piled high after the tragic 1946 fire in which four SFFD firefighters perished. (Courtesy San Francisco History Center, San Francisco Public Library.)

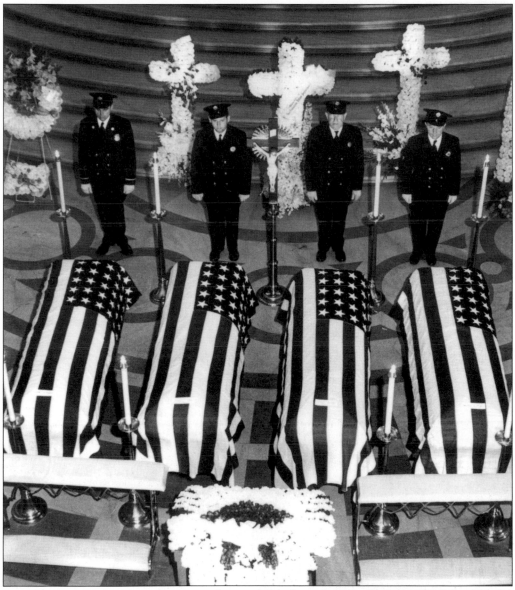

Four firemen's caskets lay in state in the rotunda of city hall in August 1946 following the Herbert Hotel fire on Powell Street. The men who gave their lives were fireman Walter V. Elvitsky, Rescue Squad 1, age 33; Lt. John Borman, Rescue Squad 1, age 35; fireman Charles P. Lynch, Salvage Corps, age 29; and fireman Albert Hudson, Rescue Squad 1, age 35. Some 427 floral pieces were sent to honor these men. The members of the honor guard are, from left to right, Lt. Louis Hage, Frank J. Kunst, Herbert Selleck, and Raymond Jensen. (Courtesy San Francisco History Center, San Francisco Public Library.)

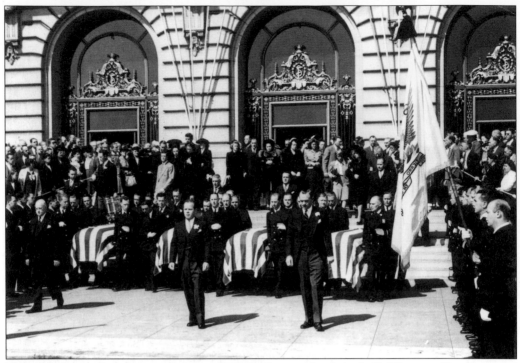

The same four caskets are seen here on the Polk Street side of city hall. (Courtesy San Francisco History Center, San Francisco Public Library.)

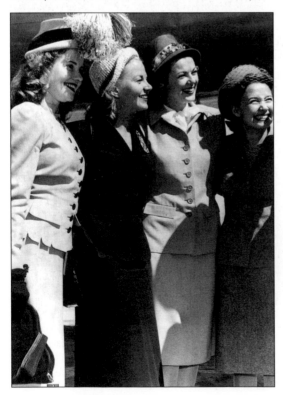

The 1946 Hotel Herbert fire brought a lot of public support. Hollywood stars came to San Francisco for a huge benefit at the Fox Theatre on Market Street. Western Airlines flew into town Joyce Reynolds, Jane Franze, Barnara Hale, and Jane Powell. (Courtesy San Francisco History Center, San Francisco Public Library.)

This August 1946 view shows the charred apparatus from the Hotel Herbert fire. Daniel Sullivan, a fire department instructor, tells a coroner's jury of finding adjusting nuts loose. The conclusion was that properly worn masks would have saved the four men that perished in the blaze from carbon monoxide asphyxiation. Others contend that this fire produced an incredible back draft situation. It required 185 firemen and 38 pieces of equipment, under the command of Assistant Chief Martin J. Kearns, to extinguish it. (Courtesy San Francisco History Center, San Francisco Public Library.)

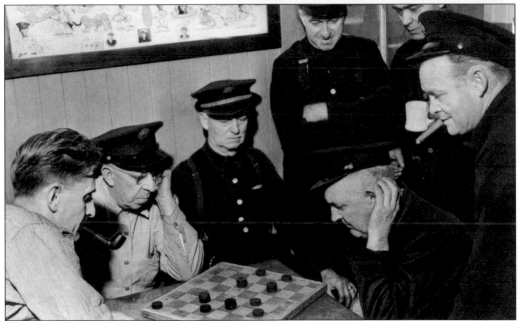

The fireboats crews at Pier 22 in January 1947, the 38th anniversary of the fireboat, pass the time on their shift by playing checkers. From left to right are Charles Foutes, Lt. Jack Rose, Julius Podesta, Lt. Bert Misisch, Capt. Ross Wright, Chief Engineer G.P. Raymond, and Anthony Maguire. At this time, the fireboats received an average of 20 calls each month. (Courtesy San Francisco History Center, San Francisco Public Library.)

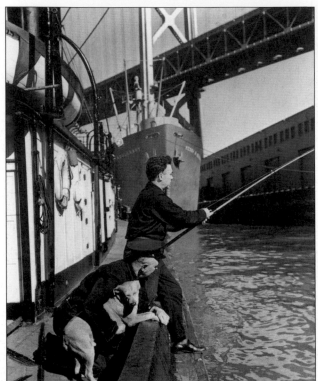

During this slow period in January 1947, fireman Julius Podesta spends time fishing in San Francisco Bay, while Lt. Jack Rose puts his arm around their canine mascot, Meatball. (Courtesy San Francisco History Center, San Francisco Public Library.)

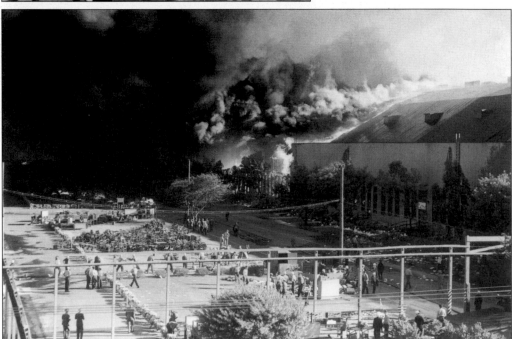

An April 1947 fire on Treasure Island destroyed six blocks. The island was the site of the World's Fair in 1939; it was then sold to the Navy in World War II and later re-acquired by the City of San Francisco. The SFFD uses the Navy's firefighting school buildings to train its staff. (Courtesy San Francisco History Center, San Francisco Public Library.)

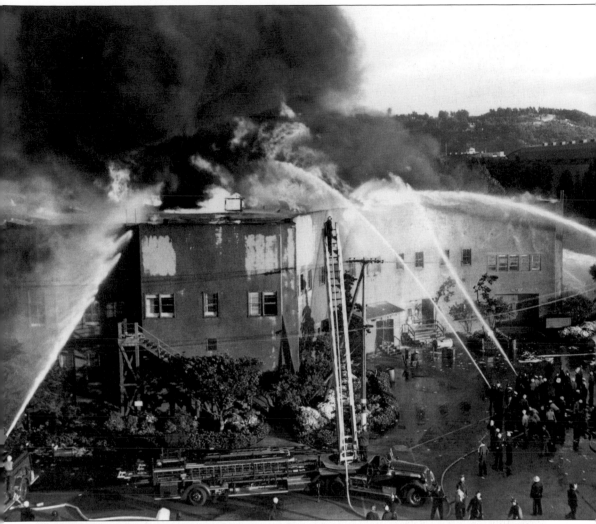

Both of these photographs show tons of water being poured onto the April 1947 island blaze. The roof collapsed on one of the six buildings that were destroyed. The flames broke out in a $^3/_4$-mile-long gallery once known as the Place of Peace during the World Fair in 1939. (Courtesy San Francisco History Center, San Francisco Public Library.)

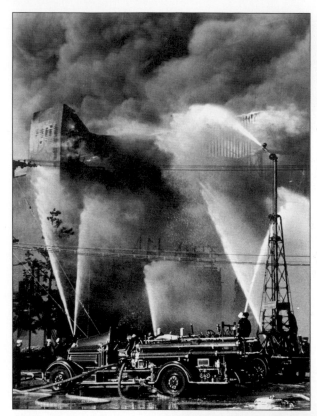

This aerial view below of the April 1947 Treasure Island fire was captured from a low-flying plane. The fire began in the bakery and consumed the world's largest mess hall, which had fed thousands during World War II. (Courtesy San Francisco History Center, San Francisco Public Library.)

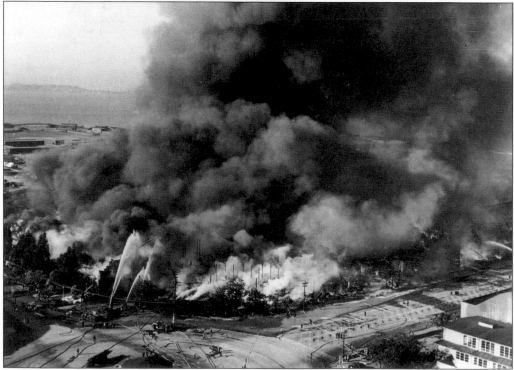

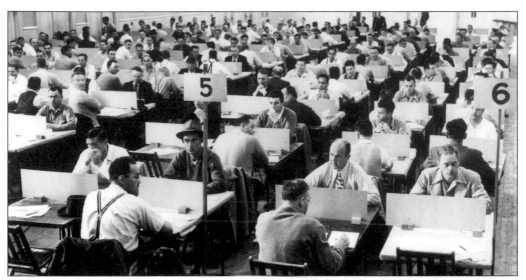

About 600 firemen strive to attain the rank of lieutenant at this June 1947 smoke-eaters exam held at Polk Hall in the Civic Auditorium. This civil service exam was the first for this rank since the end of the Second World War. (Courtesy San Francisco History Center, San Francisco Public Library.)

A friendly baseball game between the SFFD and the SFPD ended with a handshake and a 3 to 2 victory for the SFFD. This September 1948 event was called the inaugural game in the newspaper; however, a program owned by the SFFD Museum indicates that the same groups held a baseball game at Rec Park at Fifteenth and Valencia Streets in November 1910 to raise money for the late Chief Dennis T. Sullivan monument. Both departments also held golf tournaments at Lincoln Park dating back to the 1930s. (Courtesy San Francisco History Center, San Francisco Public Library.)

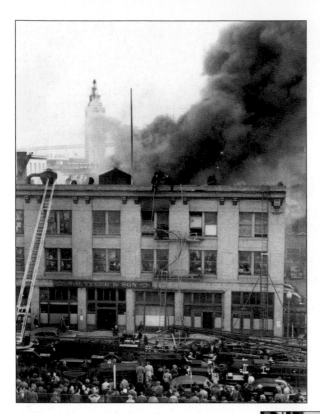

This February 1948 three-alarm fire at S.H. Tyler & Sons at 154 Davis Street filled the air with the scent of burning spices. (Courtesy San Francisco History Center, San Francisco Public Library.)

This March 1948 image shows a wooden fire escape over the boiler at the Marshal School. If a fire were to occur over the boiler, this escape route would be useless. Today, all fire escapes are made of metal. (Courtesy San Francisco History Center, San Francisco Public Library.)

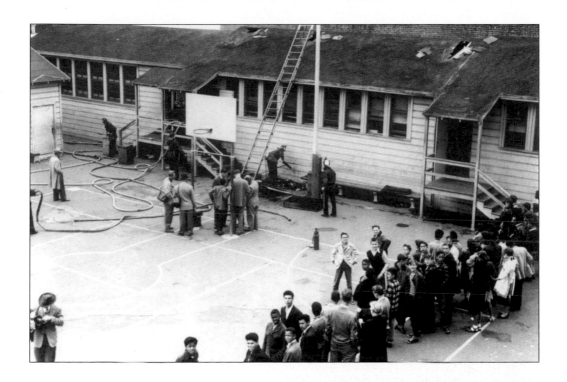

These two photographs depict the May 1948 fire at John Sweet School, located at McAllister and Franklin Streets. Notice that the firemen have already chopped holes in the roof of the school to vent the small fire. Fireman Lt. Jack Marlowe is also seen inspecting an old stove, which touched off the blaze. In the eighth-grade printing room, a student had been cleaning equipment with a type of gasoline, and this fluid exploded when it came in contact with the pot-bellied stove. Janitors were unsuccessful in putting out this fire, which caused $200 in damage. Luckily it happened between classes and only one student was in the building. (Courtesy San Francisco History Center, San Francisco Public Library.)

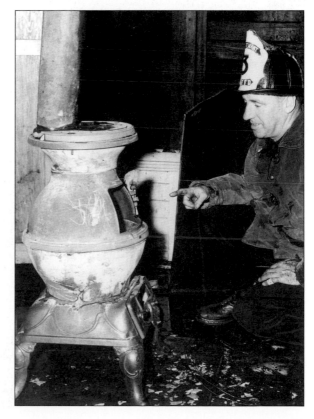

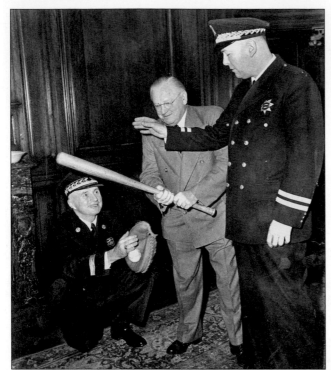

To raise funds for the city's orphans, Mayor Elmer E. Robinson promotes a charity ballgame by playing a little baseball in his city hall office in August 1948. His colleagues are SFFD Chief Edward Walsh, behind the plate, and SFPD Chief Michael Mitchell, at bat. (Courtesy San Francisco History Center, San Francisco Public Library.)

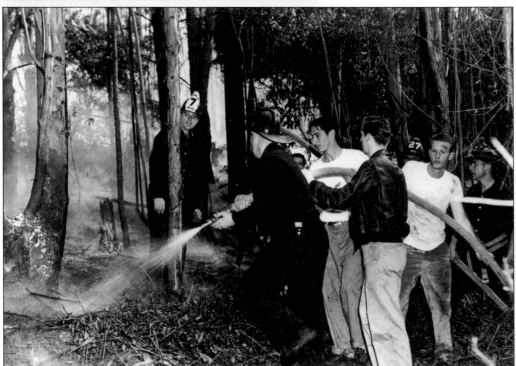

In this November 1948 scene of a fire in Sutro Forest, young men help the SFFD from Engine 7 and 27. The blaze was higher than any city reservoir, and some hoses ran through three pumpers. (Courtesy San Francisco History Center, San Francisco Public Library.)

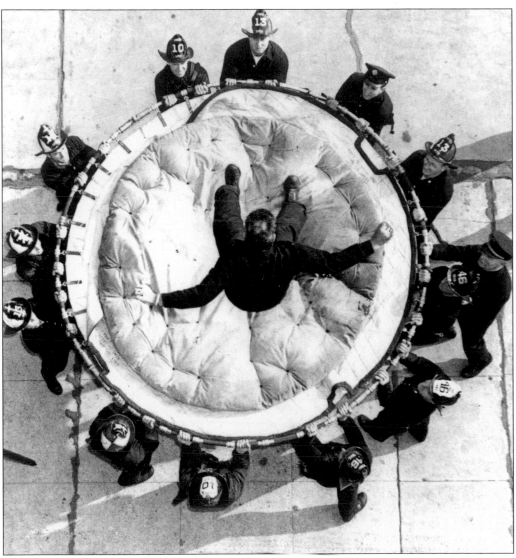

A fireman jumps into a safety net held up by 13 firemen during a practice in November 1948 at the Fire Department Training Center in the Mission district. (Courtesy San Francisco History Center, San Francisco Public Library.)

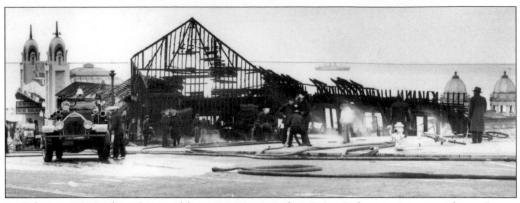

In February 1948, the 65-year-old streetcar terminal at Point Lobos sat in ruins after a 5 a.m. fire. Sutro Baths, at left, were saved this time but later burnt to the ground in a 1966 blaze. (Courtesy San Francisco History Center, San Francisco Public Library.)

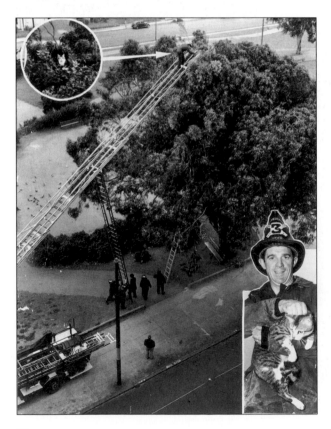

Fireman Tony Laberrigue, from Truck 3, rescues a cat from a huge eucalyptus tree in Jefferson Square in November 1949. (Courtesy San Francisco History Center, San Francisco Public Library.)

Three
1951–PRESENT

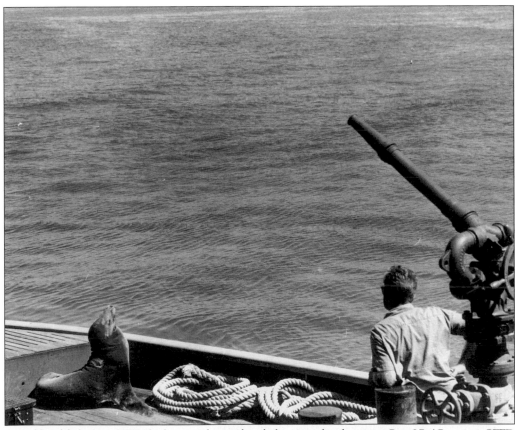

A seal hitchhikes on SFFD fireboat in this undated photograph taken near Pier 27. (Courtesy SFFD photographer Chet Born and San Francisco History Center, San Francisco Public Library.)

This 1950s trio of cooks from the firehouse at Nineteenth and Folsom are, from left to right, Frank Henry, Roy Casey, and Tom Kunst. This firehouse had 22 men, and during each shift four or five of them would prepare the meals. San Francisco firefighters are widely known for their culinary excellence, and two books have been written about their skill: *San Francisco Firehouse Favorites* (1965, Tony Calvello) and *Firehouse Food: Cooking with San Francisco's Firefighters* (2003, George Dolese and Steve Siegelman). (Courtesy San Francisco History Center, San Francisco Public Library.)

This San Francisco family is thankful that their pet was rescued by a lieutenant with Engine 33. (Courtesy SFFD photographer Chet Born and San Francisco History Center, San Francisco Public Library.)

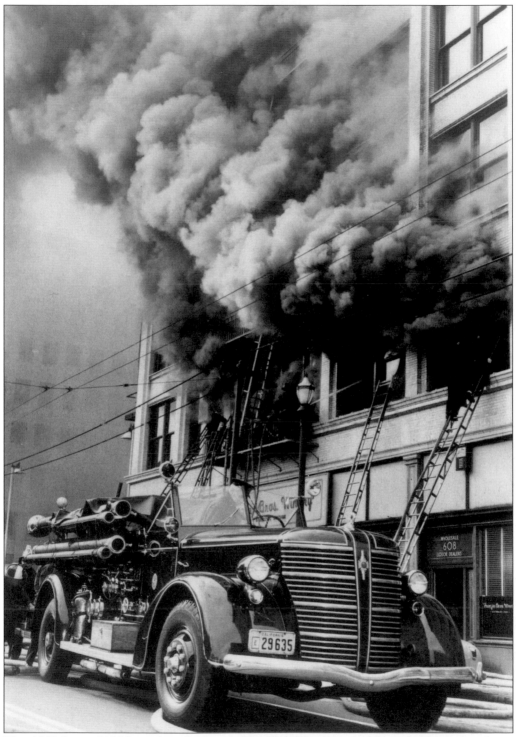

This 1950 fire at 612 Howard, with clouds of smoke billowing out of the second-story windows, did $200,000 in damage in what is now know as SOMA, or the South of Market Area. (Courtesy San Francisco History Center, San Francisco Public Library.)

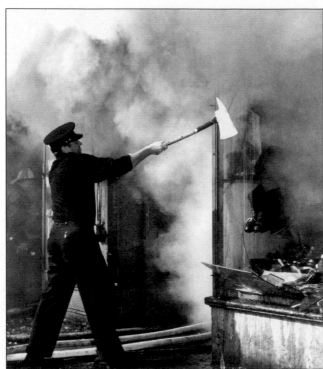

Six firemen suffered from smoke inhalation at this fire in November 1950. The location is unidentified, but the fireman with an ax appears to be venting a retail storefront. (Courtesy San Francisco History Center, San Francisco Public Library.)

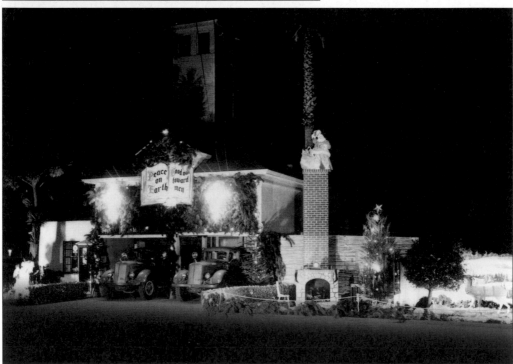

In December 1950, the Presidio Fire Department did not want to be upstaged by the SFFD's Christmas decorations, so they participated by decorating their firehouse too. (Courtesy San Francisco History Center, San Francisco Public Library.)

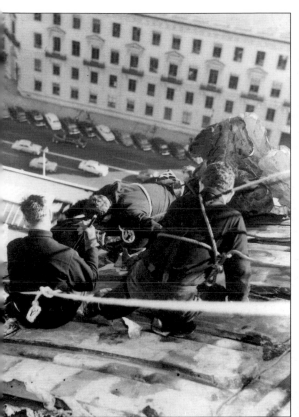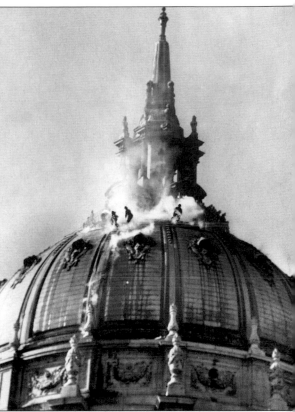

Fire broke out in the city hall dome twice—once in February 1951, when a $10,000 fire was started when a welder's torch ate into the wooden shoring beneath the copper dome, and again in February 1998, during the world's largest base isolation project, a $293-million upgrade after the 1989 Loma Prieta earthquake. The 1998 fire was also the result of a welder's torch. Both images here depict the 1951 fire and show firemen in a precarious perch, held in place just by ropes. (Courtesy San Francisco History Center, San Francisco Public Library.)

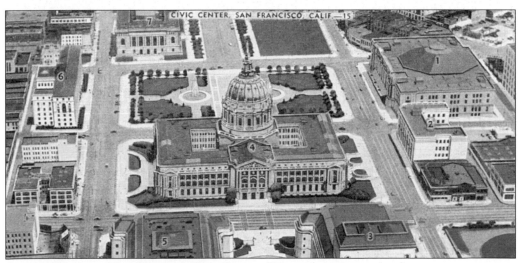

Circa 1930s view of San Francisco Civic Center. (Postcard courtesy author.)

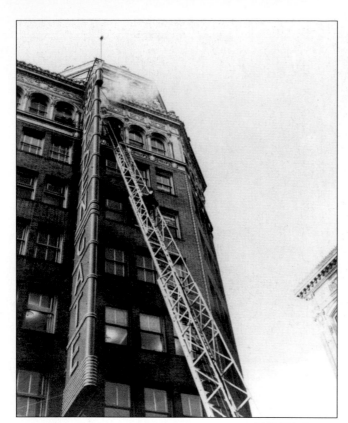

Pictured here is a fire that broke out at the famous Golden Gate Theatre in March 1951. (Courtesy San Francisco History Center, San Francisco Public Library.)

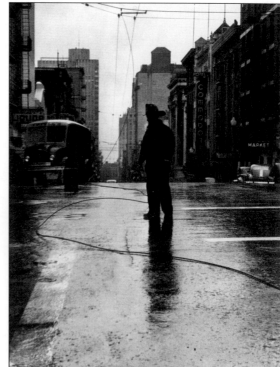

The silhouette of a SFFD fireman is visible next to a trolley wire downed by lighting at Sutter and Leavenworth Streets in August 1951. (Courtesy San Francisco History Center, San Francisco Public Library.)

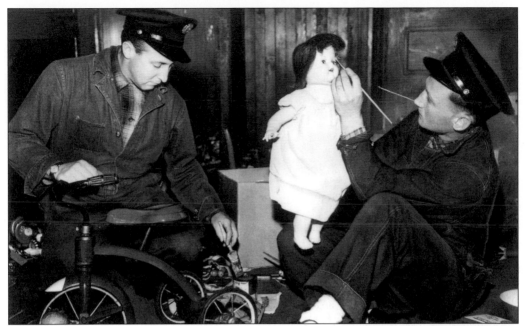

This December 1952 photograph shows firefighters Charles McCarthy (left) and Ray McTernan (right) busy with paint brushes and tools refurbishing toys for distribution to the youth of San Francisco. (Courtesy San Francisco History Center, San Francisco Public Library.)

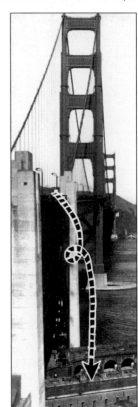

In February 1953, 49-year-old Bruce McCollum, a reputed millionaire, nationally known real estate author, and president of the Oakland Real Estate Board, leapt to his death from the Golden Gate Bridge into the inner courtyard of the Civil War–era Fort Point below. (Courtesy San Francisco History Center, San Francisco Public Library.)

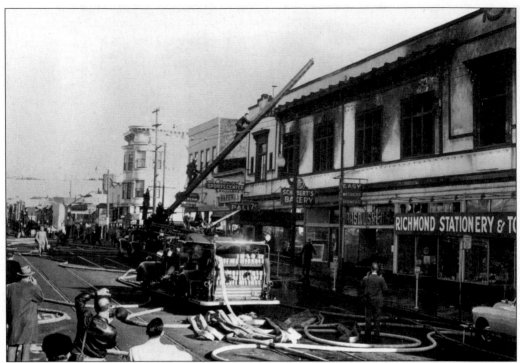

Firemen clean up after a three-alarm fire on Clement Street, between Sixth and Seventh, in February 1953. (Courtesy San Francisco History Center, San Francisco Public Library.)

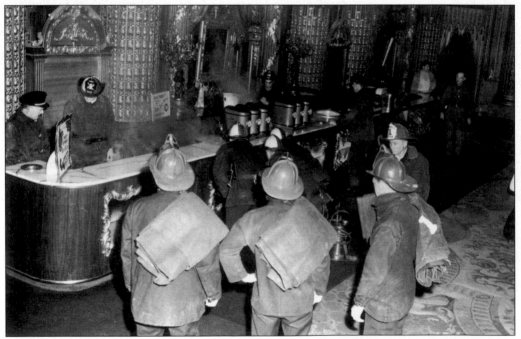

SFFD firemen are pictured at the snack bar of the world's greatest theatre, the Fox Theatre on Market Street, in November 1954. The theatre, which could seat 5,000 patrons, was destroyed by this fire. (Courtesy San Francisco History Center, San Francisco Public Library.)

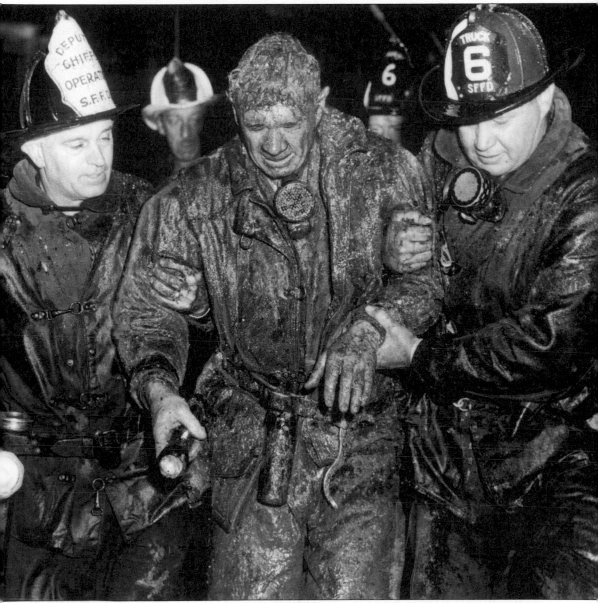

SFFD firefighter Lt. Floyd Hadley is covered with foamite at the Polk Hotel fire at 560 Polk Street. He fell four floors down a light well when he stepped on the charred floor beneath him. Hadley injured his back and also had to have medical personnel remove foreign matter from his eyes. This four-alarm blaze in 1955 killed 1 person and injured 15 others. From left to right are Barney Maloney, Floyd Hadley, Tom Rocher (white helmet), and unidentified. (Courtesy San Francisco History Center, San Francisco Public Library.)

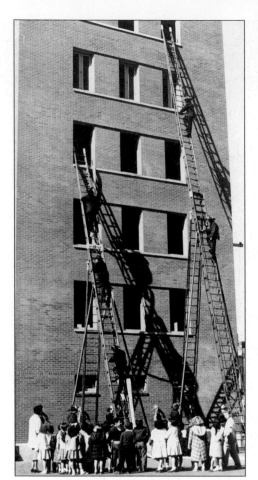

First and second graders from Hawthorne School watch firefighters in the drill tower at the Fire Department Training Center in the Mission district. In October 1955, firemen from Engine Companies 14 and 33 and Truck 10 put on an impressive field trip for the youngsters. (Courtesy San Francisco History Center, San Francisco Public Library.)

In April 1956, SFFD firemen from Truck 3 were called to city hall to unsnarl the ropes on the flagpole at Polk and Grove Streets that children had tangled as a joke. (Courtesy San Francisco History Center, San Francisco Public Library.)

In May 1956, SFFD firemen responded to a cave-in at the site of the new Masonic Memorial Temple that trapped two workmen. One was rescued by the SFFD, but the other victim was killed. (Courtesy San Francisco History Center, San Francisco Public Library.)

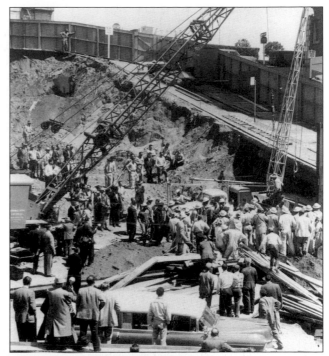

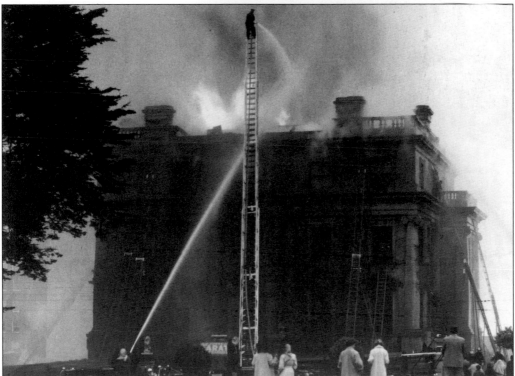

SFFD firemen fought this fire at the Irwin mansion at 2180 Washington Street in May 1956. The brownstone building once housed the Irwin Memorial Blood Bank. An arsonist was suspected. (Courtesy San Francisco History Center, San Francisco Public Library.)

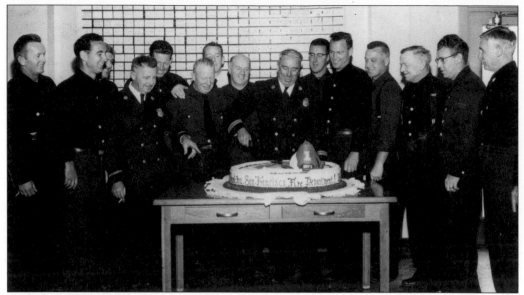

In this August 1956 photograph, the men of Engine 10, Truck 7, and Tank Wagon 11 enjoy a big thank-you cake for their June 1956 work at Blum's, where the firefighters saved invaluable candy formulas. Blum's is now long gone, but in the 1950s and 1960s, it was a very popular San Francisco candy shop. From left to right are J. Burke, R. Gallis, B. Wallace, Chief R. Minkel, T. Coutery. F. Waldyer, G. Barry, S. Cavellini, Chief W. Murray, J. Welsh, R. Casey, R. McDevitt, T. Hughes, F. Henry and T. Dalton. (Courtesy San Francisco History Center, San Francisco Public Library.)

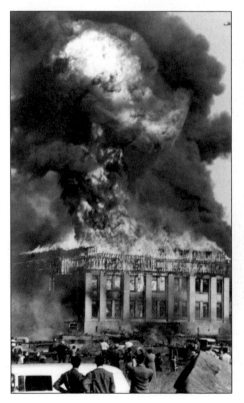

This October 1956 photograph shows the burning of the Ohio building from the 1915 Panama-Pacific Exposition; it was torched on the mud flats near the City of Belmont. The building, a replica of the Ohio State Capitol, was one of the few remaining structures from the exposition in San Francisco's Marina district. After leaving San Francisco, it became a place of drinking, gambling, and prostitution. Later, the structure housed a movie company, a machine shop, and a radar plant during World War II. It had been unoccupied for several years leading up to the fire that destroyed it. (Courtesy San Francisco History Center, San Francisco Public Library.)

Mickey, a Labrador-Dalmatian mix, was the mascot of Engine 27 and Truck 6. In January 1957 this popular dog died in the line of duty during the five-alarm Hansford Building fire. Mickey was stuck by the rear wheel of a fire vehicle while running from street to street and barking to warn pedestrians, as he usually did. This role for canines in the fire service began when the steamers just had bells and not sirens to warn pedestrians; later the job continued as tradition. Mickey was a hero who will never be forgotten. (Courtesy San Francisco History Center, San Francisco Public Library.)

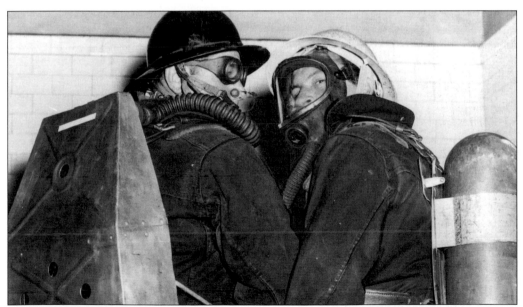

Masks are being used by SFFD in January 1957. Fireman William Buckius (left) wears a mask that is 25 years old, and Richard Webb (right) wears a mask that provides better vision and the ability to talk through a mouthpiece. At this juncture in history the SFFD had only 34 smoke masks. Fire Chief William Murray asked the popular Greek-American mayor of San Francisco George Christopher for $22,100 to buy 75 masks at $270 each and 2 resuscitators. (Courtesy San Francisco History Center, San Francisco Public Library.)

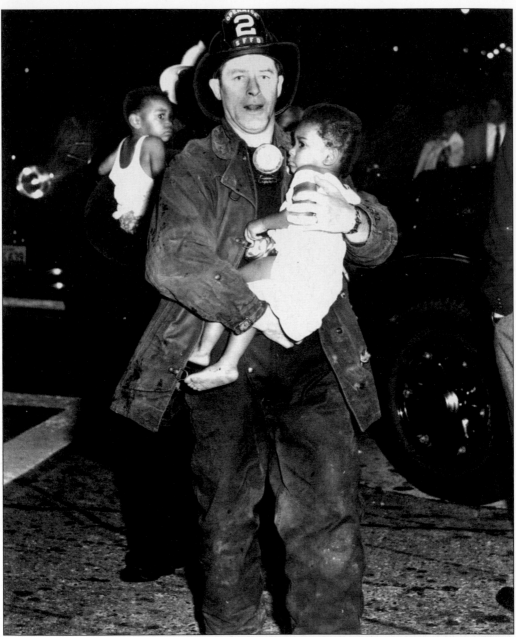

In June 1957, two unidentified firemen rescued two children from an apartment at 2927 Sacramento Street. Here, the firemen carry 18-month-old Tinkerbell Williams and her sister Dianna. Credit should be paid to a passing taxi cab driver who noticed the fire and turned in the alarm. Though race was not an issue in this rescue, at this juncture in history, the SFFD only had one African-American fireman serving in the department. However, just across the bay from San Francisco, the Oakland Fire Department had begun some all African-American firehouses in the 1920s. Women were not permitted to serve in the U.S. fire service until 1974. The first seven women entered the SFFD in 1987. In 2003, the number of women in the SFFD has grown to 212, representing 11.6 percent of the work force. With 1,622 male employees that totals 1,834 uniformed personnel. (Courtesy San Francisco History Center, San Francisco Public Library.)

In 1957, a smoke eaters service at Saint Patrick's Church on Mission Street was held on one Saturday each month to pray for the souls of dead colleagues. These men were members of San Francisco Firemen's Lady of Fatima group. (Courtesy San Francisco History Center, San Francisco Public Library.)

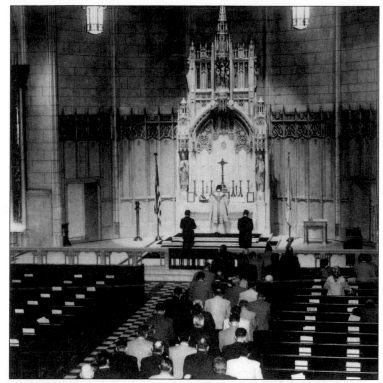

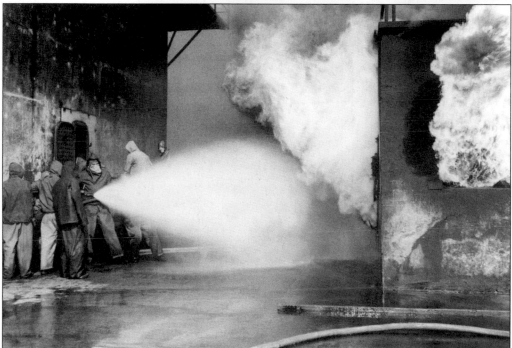

This March 1957 image shows the U.S. Navy firefighting school at Treasure Island that is now the property of the SFFD and is often used for training purposes. (Courtesy U.S. Navy and San Francisco History Center, San Francisco Public Library.)

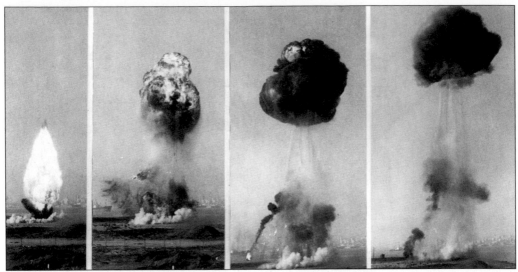

In September 1957, a mock atomic bomb was ignited on Treasure Island with TNT and gasoline in a Navy demonstration. (Courtesy U.S. Navy and San Francisco History Center, San Francisco Public Library.)

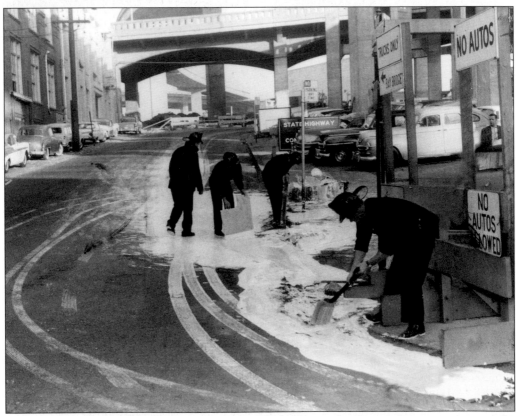

In September 1959, SFFD firemen clean up spilled paint at the Bryant Street on-ramp to the Bay Bridge. An estimated 100 gallons of paint were spilled on the road surface by a truck driver. (Courtesy San Francisco History Center, San Francisco Public Library.)

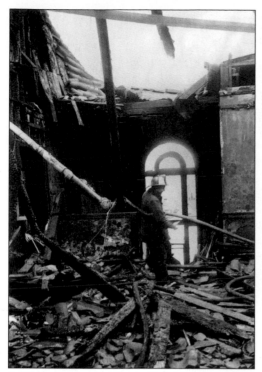

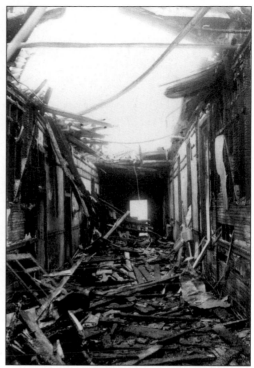

In June 1959, Battalion Chief John Howard searched for the cause of the four-alarm fire at Jefferson Elementary School, and as it turned out, a 12-year-old child was blamed for the fire. According to the *San Francisco Chronicle*, the boy allegedly "told the inspectors he touched off the $300,000 blaze by lighting a spelling paper. He said he was worried because he misspelled 'ran' in a test." (Both courtesy San Francisco History Center, San Francisco Public Library.)

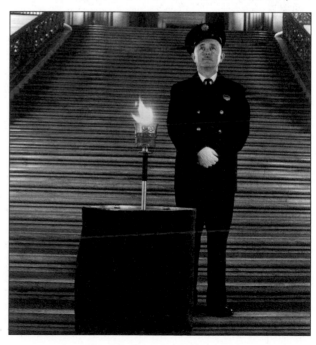

A SFFD firefighter stands guard over the Olympic flame in the rotunda of city hall while the flame is en route to the 1960 Winter Olympics in Squaw Valley. (Courtesy San Francisco History Center, San Francisco Public Library.)

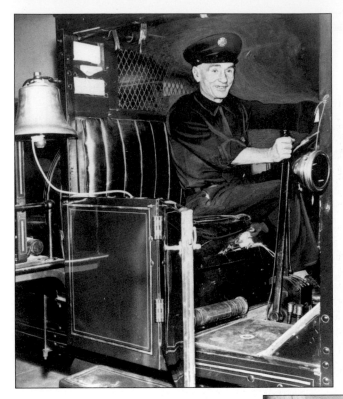

In 1957, the SFFD got rid of "Old Faithful," the box cabined fuel truck it had owned since 1916. The tires were original, and the vehicle had traveled only 1,000 miles in all its years in service. Housed at the firehouse at 299 Vermont Street, it was replaced by a new GMC truck. Fireman John Nyhan is pictured on the truck before it was replaced. (Courtesy San Francisco History Center, San Francisco Public Library.)

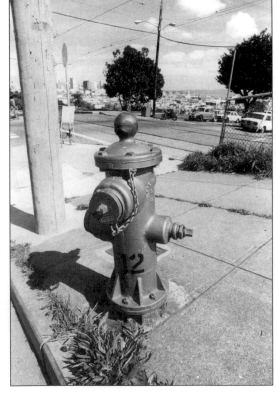

Pictured in 1961, this pre-1906 golden fire hydrant at Twentieth and Church Streets, adjacent to Dolores Park, was made by French immigrant Maurice Greenburg and Sons at their San Francisco Eagle Brass Foundry at 58 Halleck Street. This hydrant, called "The Little Giant," was the only hydrant that worked after the 1906 earthquake and helped to save the city, especially the Mission district. The hydrant is given a fresh coat of gold paint each year on the morning of the anniversary of the earthquake. Today, hydrants are color coded in the city, whether it be the entire hydrant, or just the top, to denote to firefighters the water source. (Courtesy San Francisco History Center, San Francisco Public Library.)

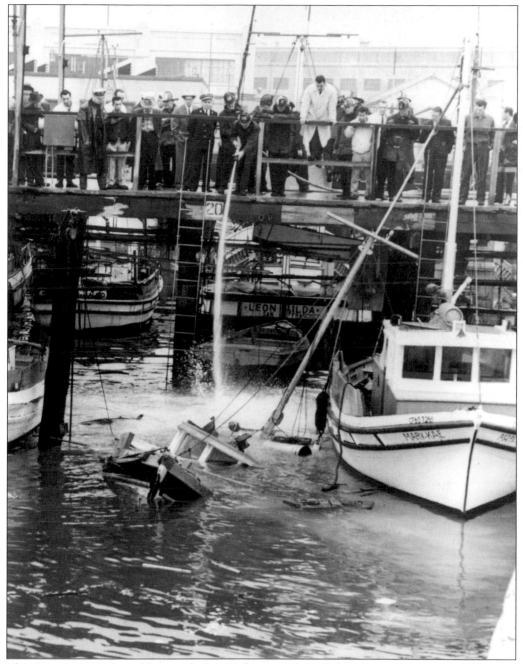

This January 1961 boat blast sunk the 35-foot crab boat *Sal Junior* at Fisherman's Wharf. A SFFD fireman sprays the boat with a hose to keep the fire contained to the one vessel. (Courtesy San Francisco History Center, San Francisco Public Library.)

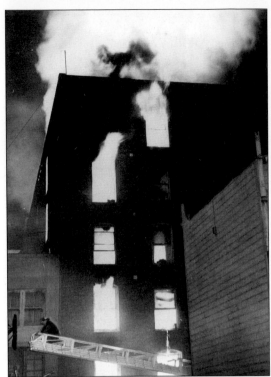

This 1961 five-alarm fire at the Thomas Hotel at 971 Mission Street saw flames reach as high as 150 feet in the air. Note that all windows are on fire. (Courtesy San Francisco History Center, San Francisco Public Library.)

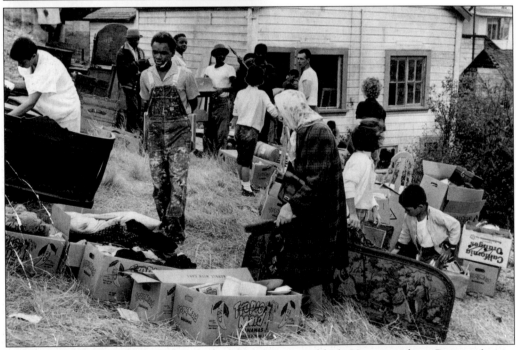

In August 1961, young people volunteer to help 81-year-old Ida Hamrin, whose Potrero district home at 951 Kansas Street was almost destroyed by vandals and fire. The volunteers donated six weeks of their time to ready the white, frame cottage home for Ms. Hamrin. (Courtesy San Francisco History Center, San Francisco Public Library.)

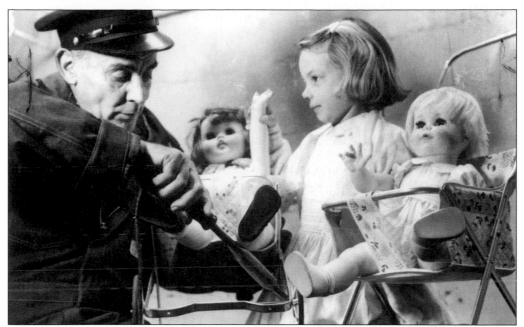

In this November 1961 photograph, fireman Guido Sturla adds a spot solder to mend the frame of a buggy for the Christmas Toy Drive as Patti Sanborn looks on. Actor John Travolta flew his airplane into San Francisco before Christmas in October 2001 and took photos with people at the historic Third Street firehouse when they donated a toy. (Courtesy San Francisco History Center, San Francisco Public Library.)

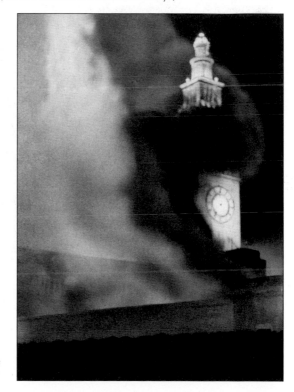

This image shows the Ferry Building on fire in July 1962. The blaze brought 100 firemen to the three-alarm event, which arson squad inspectors believe may have started as a result of a cigarette. Damage was estimated at between $75,000 and $100,000. (Courtesy San Francisco History Center, San Francisco Public Library.)

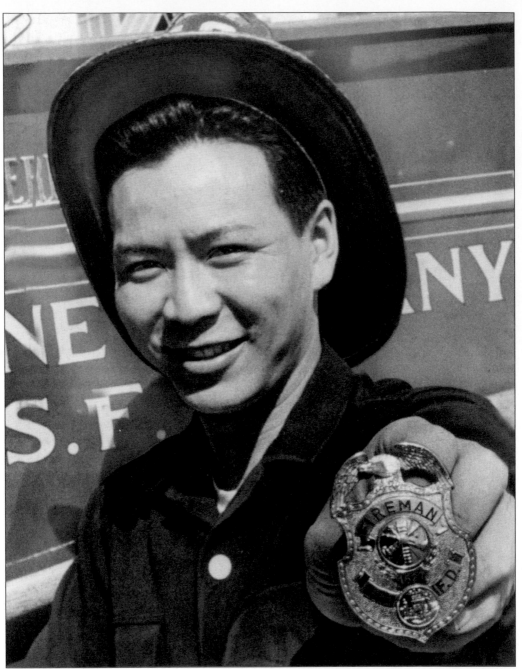

In 1963, Wylie Low became the first Chinese-American to join the SFFD as a firefighter, and firehouses all over the city put in requests for him to serve in their house. This photograph shows Low in April 1964, after finishing his six months probation, proudly displaying his hard-earned badge #1527. Low was stationed at Fire Station 35 and the fireboat, and retired as an inspector. Continuing in his footsteps are two of Low's nephews, Jon M. Low and Gregory Louie. Low died on May 19, 2001 of cancer at the young age of 63. The first woman of Asian descent to enter the SFFD was Theresa Gee, who joined Engine Company #9 in 1990. (Courtesy San Francisco History Center, San Francisco Public Library.)

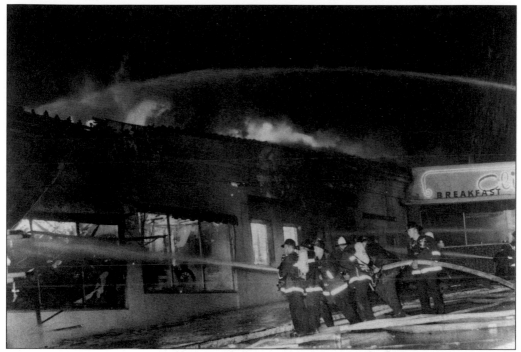

This November 1963 photo shows the five-alarm fire that burned at the Sutro Baths. The skating rink and museum were saved by the SFFD in this nighttime blaze. (Courtesy San Francisco History Center, San Francisco Public Library.)

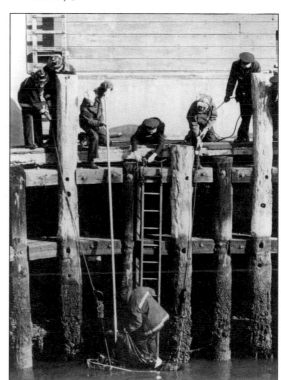

Occasionally firefighters in San Francisco retrieve badly decomposed bodies from the bay. This lifeless human body was plucked from the cold water in May 1964 at Pier 3. (Courtesy SFFD photographer Chet Born and San Francisco History Center, San Francisco Public Library.)

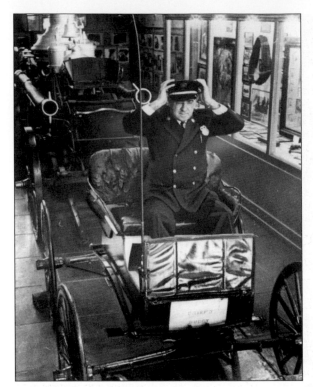

The chief's buggy appears in this October 1964 photograph taken inside the SFFD Museum. Seated in the chief's seat is Capt. John Thomson of Truck 10. Sorry Chief! The *c.* 1910 buggy appeared at start of the horseless age and could reach a maximum speed of eight miles per hour. Legend has it that the SFFD would stage races up California Street from the Embarcadero to Nob Hill to see if horses or these early cars would win. The cars, trucks, and engines eventually won out, and horses were removed from service in the early 1920s. (Courtesy San Francisco History Center, San Francisco Public Library.)

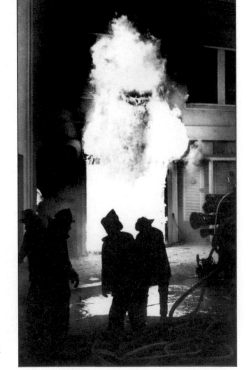

Flames leap from 4879 Mission Street in this October 1964 fire. (Courtesy SFFD photographer Chet Born and San Francisco History Center, San Francisco Public Library.)

All SFFD rescue squad personnel are certified in Self Contained Underwater Breathing Apparatus (SCUBA). This truck was recovered from the bay at Pier 52 in October 1964. (Courtesy SFFD photographer Chet Born and San Francisco History Center, San Francisco Public Library.)

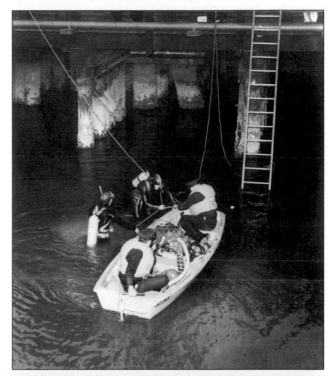

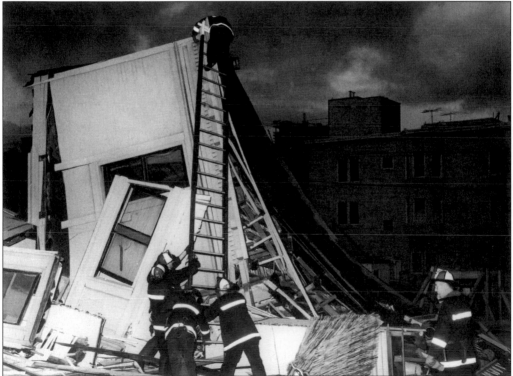

In December 1964, SFFD firemen responded to this collapsed building at Grant and Lombard Streets in Telegraph Hill. (Courtesy San Francisco History Center, San Francisco Public Library.)

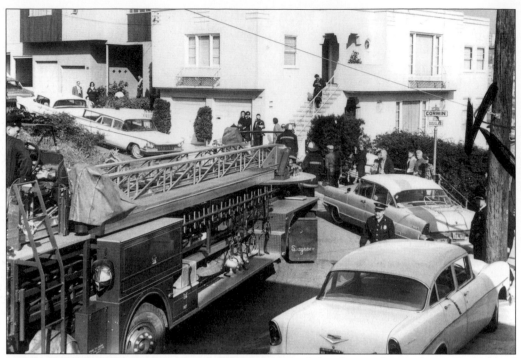

In March 1965, SFFD firemen tested a theory put forth by the residents of tiny Seward and Corwin Streets that the SFFD ladder truck could not service a proposed 69-unit house at the dead-end Corwin Street. The test was authorized by Fire Chief William Murray. (Courtesy San Francisco History Center, San Francisco Public Library.)

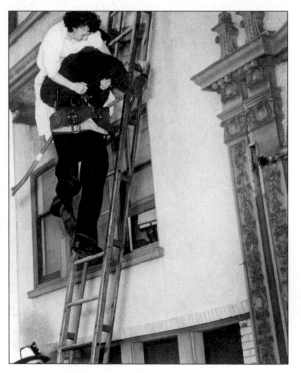

Fireman Dave Hinman carries Ellen Lovald out of an Oak Street fire in this April 1965 photograph. (Courtesy SFFD photographer Chet Born and San Francisco History Center, San Francisco Public Library.)

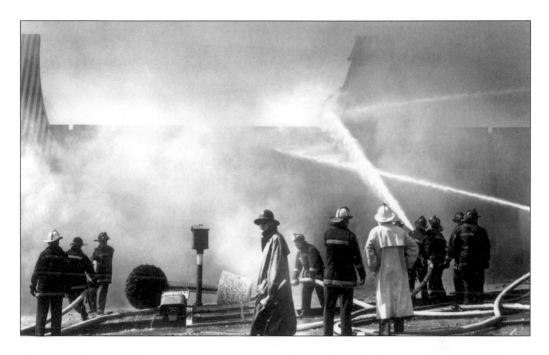

These two June 1966 images show yet another fire at Sutro Baths, near the Cliff House in Ocean Beach, and this time, the daytime fire finally destroyed the famous baths that had been a saltwater playground for generations of San Franciscans. (Courtesy San Francisco History Center, San Francisco Public Library.)

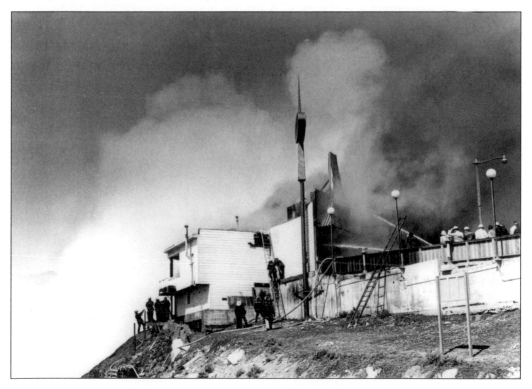

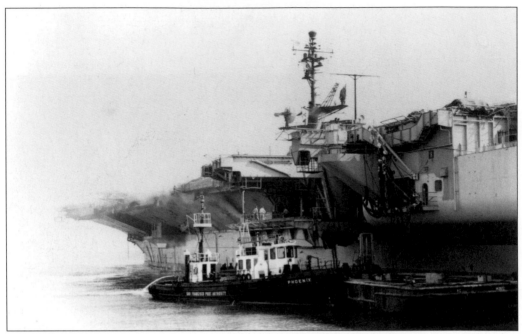

In April 1966, during the early stages of the Viet Nam War, the fireboat *Phoenix* sails by an aircraft carrier at Hunters Point Naval Station. (Courtesy San Francisco History Center, San Francisco Public Library.)

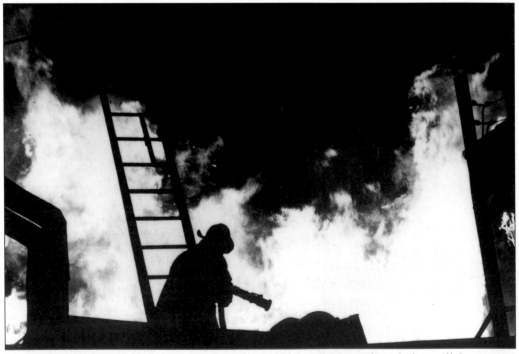

Firefighters remember the big fires, and this 1967 blaze at Fourteenth and Shotwell Streets was one that would stick in their minds. (Courtesy SFFD photographer Chet Born and San Francisco History Center, San Francisco Public Library.)

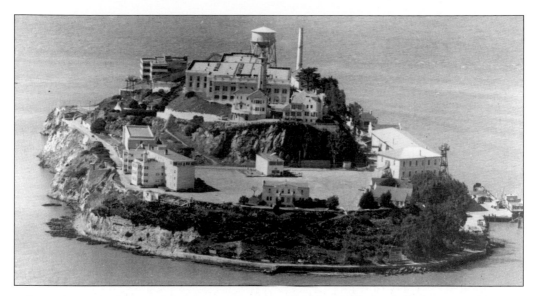

When Alcatraz had been a federal prison (1934–1963), the SFFD assisted the Bureau of Prisons in firefighting oversight and operations, should the need arise. The above view of Alcatraz from San Francisco was taken in April 1970, five and a half months into the 19-month American Indian occupation of the island. On May 30, 1970, hundreds of Indians came to Alcatraz to challenge Interior Secretary Walter Hickel's intention to turn Alcatraz into a national park. That evening, as a thick fog covered the bay, the group set fires to many of the buildings that were left standing in defiance of a country that had turned its back on their proposal. The spectacular blaze destroyed the historic lighthouse, the home of the prison physician, the three-story warden's house, a Coast Guard residence, and the fog signal building. Initially, the Indians maintained their innocence, but eventually islander Joseph Morris said that Indians were responsible for the fires. The Indians also admitted to setting a fire at the island dock to prevent the Coast Guard from making a landing. Today the island is a national park and a national historic landmark. In September 2003, the prison's 1934 Diamond T fire truck returned fully restored to Alcatraz, after it left in 1970 on a barge in disrepair. (Courtesy Darrell Duncan and San Francisco History Center, San Francisco Public Library.)

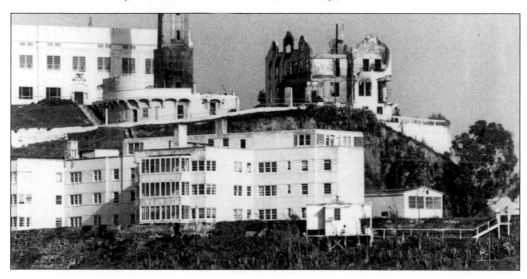

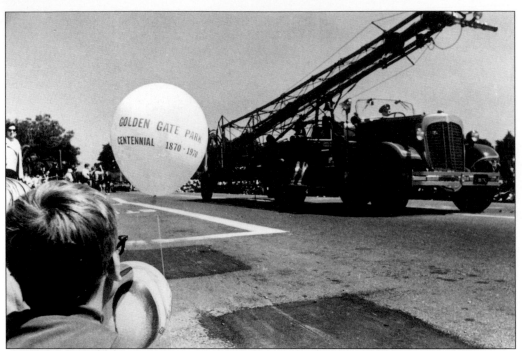

A fire engine water tower is pictured at the Golden Gate Park Centennial Parade in April 1970. (Courtesy San Francisco History Center, San Francisco Public Library.)

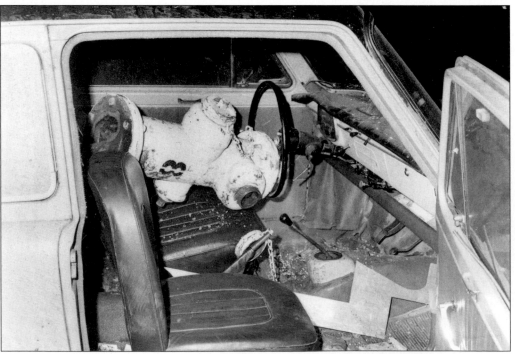

Yes, this fire hydrant really did end up in the front seat via the rear window in this automobile accident, which occurred in September 1970 at Silver and University. (Courtesy SFFD photographer Chet Born and San Francisco History Center, San Francisco Public Library.)

Fireman Ed Mitchell makes a rescue in Chinatown in December 1970. (Courtesy SFFD photographer Chet Born and San Francisco History Center, San Francisco Public Library.)

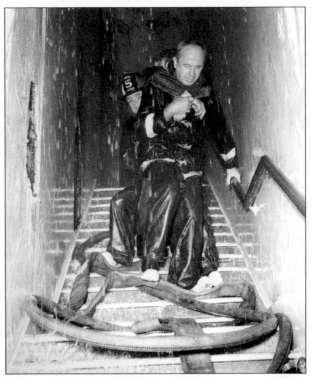

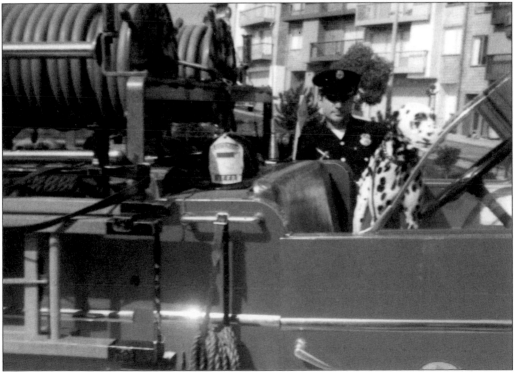

Spreckles the dalmation in the front seat of a fire engine parked on the 5500 block of Diamond Heights Boulevard in May 1972.

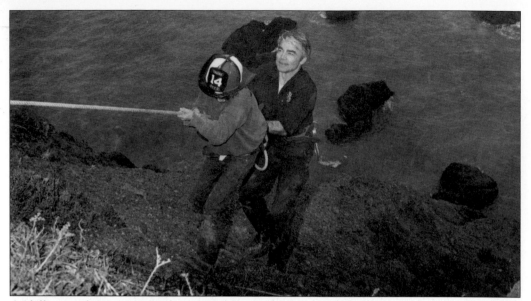

A cliff rescue by Ocean Beach and Seal Rocks is pictured here in February 1971. Notice how the Engine 14 firefighter, who is unidentified, with little regard for his own safety gives his head protection to the victim as they ascend the perilous cliff via a rope. (Courtesy SFFD photographer Chet Born and San Francisco History Center, San Francisco Public Library.)

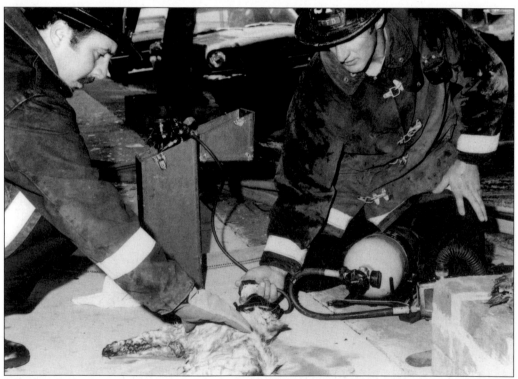

This lucky cat receives oxygen from a firefighter in May 1972 at Fourteenth and Alpine Streets. (Courtesy SFFD photographer Chet Born and San Francisco History Center, San Francisco Public Library.)

These November 1973 images show a SFFD water tower engine and a SFFD Ahrens-Fox, on public display in Union Square. It was during 1974 that a yearbook was first published by the SFFD and the department began to get serious about preserving its unique history as a municipal asset. (Courtesy San Francisco History Center, San Francisco Public Library.)

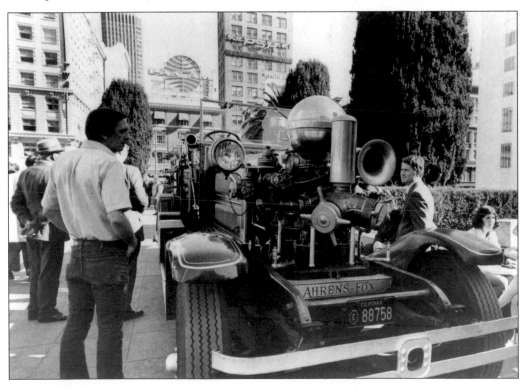

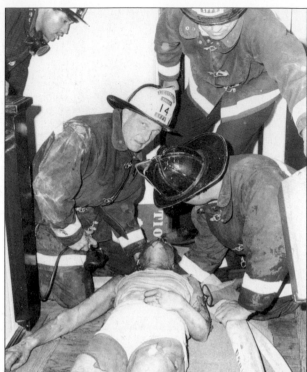

A burn victim is rescued and assisted by Truck 14 personnel in May 1972. Note the African-American firefighter on the upper left. This photograph was the only image depicting an African-American firefighter that this author could find in the archives. Earl Gage was the first African-American firefighter in the SFFD and the only one to serve between 1955 and 1967. Today, the ranks are well integrated with all races, genders, and sexual orientations. The department now much more closely reflects the community it serves. (Courtesy SFFD photographer Chet Born and San Francisco History Center, San Francisco Public Library.)

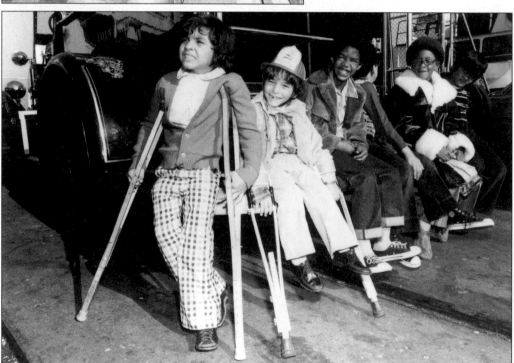

This November 1974 photograph shows students from Sunshine Orthopedic School sitting on the back of a SFFD fire truck. That day the SFFD hosted these youngsters on a bay cruise. (Courtesy San Francisco History Center, San Francisco Public Library.)

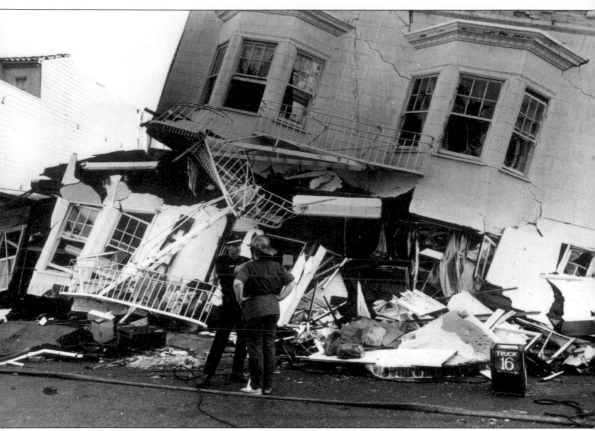

Two SFFD firefighters, possibly from Truck 16, stand in front of a building destroyed in the October 17, 1989 Loma Prieta earthquake. (Courtesy San Francisco History Center, San Francisco Public Library.)

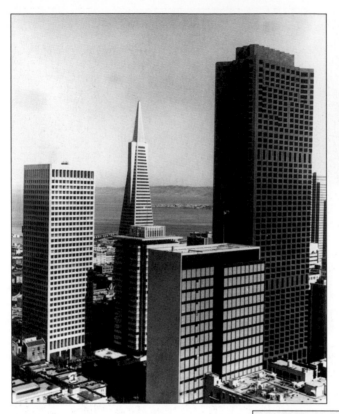

The tallest buildings in San Francisco are the Transamerica Pyramid (1972) on Montgomery Street, at 853 feet and 48 stories high, and the Bank of America building (1969) on California Street, at 779 feet and 52 stories high. The latter building was used in the 1974 film *The Towering Inferno*, starring Steve McQueen and Paul Newman. Aerial ladders on SFFD trucks can only reach seven stories. (Courtesy San Francisco History Center, San Francisco Public Library.)

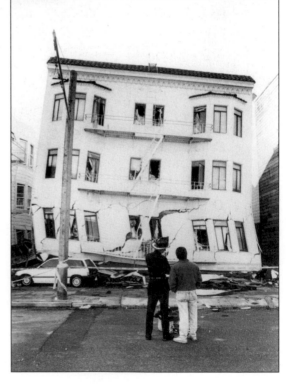

A SFFD fireman and another person look at a building destroyed in the Loma Prieta earthquake. The man was possibly a resident of the area, as some people were given limited access to damaged buildings. (Courtesy San Francisco History Center, San Francisco Public Library.)

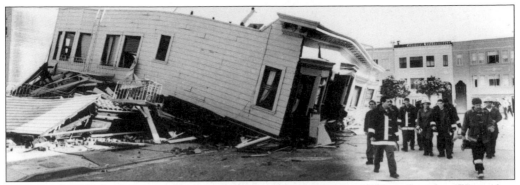

A group of SFFD firefighters walk past a building destroyed by the 1989 earthquake. When they reported to the Marina district on the night of the earthquake, they quickly learned that all the water lines in a 40-square-block area surrounding the fire were broken and useless. But Division Fire Chief Harry Brophy called for the *Phoenix* fireboat and the department's Portable Water Supply System (PWSS) invented by SFFD's Assistant Chief Frank Blackburn in 1984. Within an hour of being set up, the fire was under control. The San Francisco Board of Supervisors rewarded Blackburn with a commendation, and Supervisor Terrance Hallinan stated "without those portable hydrants, along with the fireboat, the city probably would have burned to the ground." Since 1989, fire departments around the globe have come to San Francisco to learn more about the PWSS. (Courtesy San Francisco History Center, San Francisco Public Library.)

Of particular interest in this photograph of author John Garvey in the Marina district on the day after the 1989 earthquake is that visible in the bottom left is a PWSS device. This spot was very near where the *Phoenix* was hard at work pumping water from the bay, operating continuously for 15 hours with two pumps wide open and providing over 5.5 million gallons of water. After the 1898 earthquake, a second boat, *Guardian*, was a gift from the people of San Francisco and was partially funded by two anonymous donors who gave $300,000 towards the purchase. At the request of the donors, schoolchildren were asked to name the new boat in a contest. Christopher Smith, age 6, of Saint Cecilia's won. Unknown to the judges, Christopher's father was a SFFD fireman. (Courtesy John Jew.)

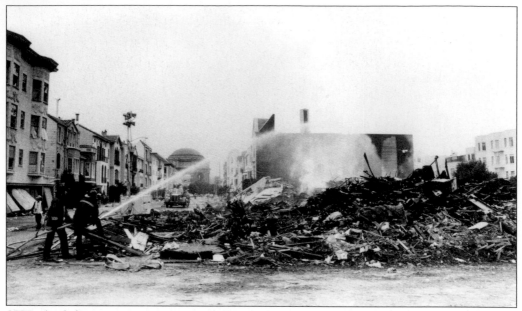

SFFD firefighters spray water on all that is left of one Marina district property. These firefighters were thankful for the help of the fireboat *Phoenix*, as well as for the foresight of city engineer O'Shaughnessy, who planned San Francisco's water system. In 1915, Michael O'Shaughnessy stated, "I have visited New York, Boston, Philadelphia, and Baltimore, studying their fire protection systems. I can unhesitatingly state that the system constructed in San Francisco is superior to any other in this country, the best in the world." (Courtesy San Francisco History Center, San Francisco Public Library.)

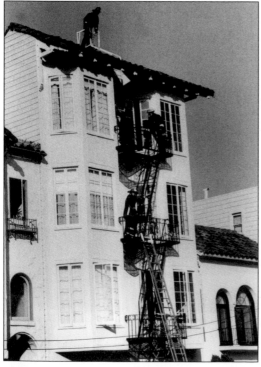

Firefighters climb the fire escape of a property on October 17, 1989 just after the earthquake hit. (Courtesy San Francisco History Center, San Francisco Public Library.)

Fire Chief Robert L. Demmons (1996–2000) was San Francisco's first African-American chief, an appointment he earned in January 1996 after 22 years of service in the SFFD. He is shown here congratulating Erika Hoo. Women firefighters also populate the ranks of the SFFD. In 1995, during a fire at a Diamond Heights home, firefighters became trapped in a residential garage. A 25-year-veteran, Louis Mambretti, died in the blaze, and Melanie Stapper became the first female firefighter to be seriously hurt in the line of duty. (Courtesy San Francisco Fire Department.)

San Francisco Fire Department

Award of Achievement

The San Francisco Fire Department and Chief of Department Present This Award to:

John Garvey

on the successful completion of the Neighborhood Emergency Response Team Training. You are recognized and commended for your voluntary participation in this program.
Presented on February 15, 1994.

Joseph A. Medina
CHIEF OF DEPARTMENT

This Neighborhood Emergency Response Training (NERT) certificate was issued to the author on February 15, 1994 by former SFFD Chief Joseph A. Medina. NERT was begun after the 1989 earthquake after some realized that, in a disaster, emergency services would be overwhelmed and that people living and working in San Francisco must be trained. The program teaches citizens earthquake awareness, hazard mitigation, utility control, disaster fire suppression, hazardous materials, disaster medicine, light search and rescue, team response and management, and disaster exercise. To date over 10,000 people have been trained. (Courtesy author.)

During the early 1990s, author John Garvey started the SFFD Oral History Program with Karen Hanning, Marina Garris, and Chuck Burwell. Pictured here are (left) fire fighter Bill Maloney and (right) Chief William Murray who participated in the program in 1991. Fireman Maloney related many interesting things about his experiences, including how firemen had to buy their uniforms, equipment, and beds; how the physical included lifting a 150-pound sack of sand to your shoulders; and how since there was no fire academy in the late 1940s, it was all on-the-job training! It is important to remember the saying: "When a person dies, a library burns to the ground." (Courtesy author.)

Pictured here is the current SFFD Chief Mario Trevino. The very first chief engineer of the Volunteer Fire Department was Fredrick D. Kohler. The later SFFD chiefs are listed here: Franklin Eugene Raymond Whitney (December 3, 1866–1870), David Scannell (1871–1883), Dennis T. Sullivan (1893–1906), Patrick H. Shaghnessy (1906–1910), Thomas R. Murphy (1910–1929), Charles J. Brennan (1929–1943), Albert J. Sullivan (1943–1948), Edward P. Walsh (1948–1953), Francis P. Kelly (1953–19560, William F. Murray (1956–1971), Keith P. Calden (1971–1976), Andrew C. Casper (1976–1982), Emmet D. Condon (1982–1987), Edward J. Phipps (1987–1988), Fredrick F. Postel (1988–1992), Joseph A. Medina (1992–1996), Robert L. Demmons (1996–2000), and Mario H. Trevino (2000–present. Chief Trevino was previously the fire chief of Las Vegas, Nevada, and like his predecessor, was a trailblazer in the department being the first Latino fire chief of the SFFD. The first woman made an honorary chief (men had been given this honor before) was Louise M. Davies, who through her love and generosity, helped to preserve SFFD history for future generations. (Courtesy San Francisco Fire Department.)

Infant Sean Garvey is pictured here at the SFFD Museum in 1998 next to one of the 2,000 red alarm boxes in San Francisco. In a rush to be born, Sean never made it to the hospital but was delivered at home by the Moraga-Orinda Fire Departments. It was the first baby delivery for these firefighters since the two cities merged fire services. (Courtesy author.)

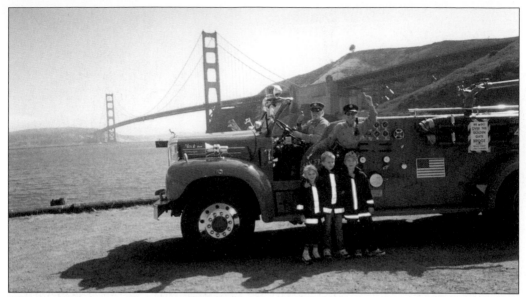

What a way to spend your eighth birthday! Birthday boy Geoffrey Ringlee, his sister Lindsey, and Christopher Garvey are pictured with Marilyn and Bob Katzberg in a shiny red 1955 Mack fire engine. The couple owns old Firehouse 33 on 119 Broad Street near San Francisco City College and they take people around town on their very own San Francisco fire engine, which they own and operate as part of San Francisco Fire Engine Tours and Adventures. (Courtesy Mrs. Patti Ringlee.)

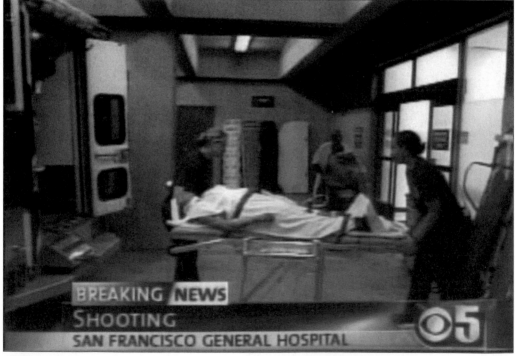

BREAKING NEWS
SHOOTING
SAN FRANCISCO GENERAL HOSPITAL

SFFD firefighters and paramedics encounter life and death situations daily. (Courtesy San Francisco Fire Department.)

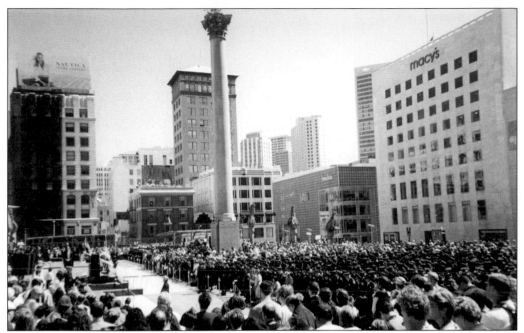

This is a view of Union Square on September 11, 2002. More than 20 SFFD firefighters traveled to New York City at their own expense to aid in the efforts at Ground Zero in the prior year. Despite the funds that were donated to underwrite their missions of mercy, all wanted to bear the travel expenses themselves and they gave all the cash donated to the families of the fallen firefighters. The following SFFD firefighters volunteered to travel to New York City: Lt. Daniel Armenta, Jeffery Barden, Michael Cochrane, Dean Crispen, Stephen Engler, John Fogerty, T/Capt. Pat Gardner, Daniel Gracia, Sean Johnson, Jeffery Moreno, Tom O'Connor, Derek O'Leary, Michael Orland, Bruce Platt, Thomas Rey, Kevin Salas, John Shanley, John Sikora, Britton Smith, Lt. Leslie Steinhoff, and Lt. Victor Wyrsch. Bob Boudoures took a special, three-week Red Cross assignment to help with logistics in New Jersey. (Courtesy author.)

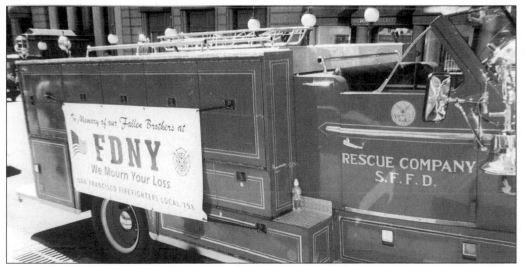

SFFD Rescue Company vehicle parked at Union Square with a sympathy banner for FDNY. (Courtesy author.)

Line of Duty Deaths

1. James Welsh, May 4, 1851
2. James Dougherty, June 22, 1853
3. Samuel Bumm, March 2, 1854
4. John Teising, November 28, 1854
5. Thomas Murray, January 27, 1855
6. T.T. Seward, November 2, 1855
7. William Louderbach, August 20, 1859
8. Elbert Barbier, November 27, 1860
9. Edward T. Allen, March 1, 1863
10. J.M. Jacks, August 31, 1863
11. Walter J. Bohen, August 31, 1865
12. F. Kiernan, November 4, 1879
13. John Chester, July 5, 1880
14. Mathew Brady, November 21, 1882
15. John E. Ross, April 3, 1883
16. Michael McLaughlin, June 10, 1885
17. Gabriel Beaujet, November 10, 1885
18. Martin H. Hannan, October 8, 1885
19. Peter F. Healy, October 8, 1885
20. William B. Ludlow, January 2, 1886
21. John P. Flemming, May 1, 1886
22. Greg L. Post, August 23, 1886
23. John J. Wilkinson, February 10, 1887
24. John M. Cook, June 28, 1887
25. Michael J. Nagle, November 25, 1887
26. Edward Riley, November 29, 1890
27. William Hunt, July 4, 1891
28. Thomas Kennedy, May 20, 1892
29. A.E. Davis, June 7, 1893
30. Joseph Madison, June 7, 1893
31. Richard Windrow, June 7, 1893
32. Morris Bushway, August 9, 1893
33. John Cronin, October 6, 1893
34. John. B. Peralta, November 11, 1893
35. James Bain, January 15, 1895

36. John Moholy, January 6, 1897
37. Timothy Hallinan, January 6, 1897
38. Michael Kellehar, October 30, 1898
39. Henry O'Neil, May 11, 1900
40. John E. Sweeney, November 20, 1900
41. Henry T. Heffeman, September 24, 1902
42. Mark Bearwald, June 23, 1903
43. Charles W. Dakin, January 31, 1906
44. Tim J. Hennessy, January 31, 1906
45. Henry Sullivan, April 15, 1906
46. Dennis T. Sullivan, April 18, 1906
47. James O'Neil, April 18, 1906
48. Greg F. Wells, June, 1908
49. Thomas F. Hayden, December 6, 1908
50. John H. Mullen, October 14, 1909
51. Phillip J. Meehan, November 1, 1910
52. Frederick J. Baker, September 3, 1910
53. James C. Crowley, January 26, 1911
54. James Buckley, May 31, 1911
55. Thomas J. Ahern, March 17, 1912
56. John F. Meacham, June 28, 1914
57. William W. Nelfer, July 5, 1914
58. William A. Carew, September 9, 1914
59. Dennis J. Mulcahy, November 7, 1915
60. John W. Corwell, June 2, 1916
61. Joseph Allen, October 5, 1917
62. Stephen D. Russell, October 5, 1917
63. Timothy F. Collins, October 5, 1917
64. Joseph H. Coleman, November 27, 1917
65. John J. Conlon, March 2, 1919
66. Theodore B. Kentzel,

April 25, 1919
67. Joseph Ryan, 1919
68. Owen Williams, June 7, 1920
69. Bernard F. McDermott, October 9, 1920
70. William J. Cooper, January 9, 1922
71. William S. Kirkpatrick, January 9, 1922
72. Anton Loger, Janaury 9, 1922
73. Julius Phillips, January 25, 1923
74. Frank W. Becker, October 29, 1924
75. James C. Herlihy, June 15, 1925
76. John D. Lavaroni, April 14, 1925
77. Thomas F. Collins, May 2, 1925
78. Patrick W. Gordon, August 28, 1926
79. David J. Britt, January 1, 1927
80. William H. Bowen, March 1, 1931
81. Florence Scannel, January 1, 1932
82. Timothy J. Driscoll, March 9, 1932
83. Joseph A. Sullivan, July 31, 1936
84. Owen E. McNulty, August 10, 1937
85. William Larkin, February 15, 1938
86. Patrick T. Dunlavy, May 15, 1938
87. James O'Malley, June 5, 1938
88. Michael F. Malley, February 13, 1939
89. Joseph F. Flood, August 24, 1940
90. Louis E. Sullivan, September 27, 1940
91. Harry D. Brophy, December 4, 1941
92. Arthur F. Moore, December 5, 1941
93. Charles J. McCarthy, January 30, 1942
94. John W. Walker, July 24, 1944
95. Frank J. Garcia, December 7, 1944
96. James Byrnes, July 25, 1946

97. John M. Borman, July 30, 1946
98. Albert F. Hudson, July 30, 1946
99. Walter V. Elvitsky, July 30, 1946
100. Charles P. Lynch, July 30, 1946
101. Patrick Duffy, January 2, 1947
102. Michael O'Connell,
 October 17, 1947
103. Leo J. Carey, March 18, 1948
104. Joseph F. Kane, May 15, 1948
105. John J. Webb, January 17, 1950
106. Fred C. Ellenberger,
 April 13, 1950
107. Alfred W. Betti, June 12, 1952
108. George J. Kennan, July 28, 1952
109. Joseph P. Corliss, March 6, 1953
110. George R. Wyatt,
 October 2, 1953
111. Herbert G. Martin,
 April 7, 1954
112. Arthur O. Lindberg,
 September 6, 1958
113. Stanislaus J. Rybicki,
 February 4, 1960
114. Nicholas P. Pearson,
 January 1, 1961
115. Daniel P. Feeney,

February 2, 1962
116. Joseph B. Cuff, July 12, 1962
117. Frank M. Lamey,
 January 2, 1963
118. Robert V O'Rourke,
 January 2, 1963
119. Patrick G. Brannigan,
 June 3, 1963
120. Andrew K. Benton,
 November 1, 1964
121. Thomas R. Finerty,
 October 20, 1964
122. Bennie Kinsey,
 October 20, 1964
123. Albert Gheno,
 October 21, 1964
124. Cornelius J. Lucey,
 January 10, 1965
125. Raymond C. Ring,
 February 20, 1966
126. Thomas F. Lyons,
 January 21, 1968
127. Fred L. Baumeister,
 September 2, 1968
128. Gary Nisidio, March 21, 1969
129. Robert L. Hutchinson,

May 22, 1970
130. Joe Intersimone,
 September 4, 1970
131. William A. Johnston,
 January 10, 1971
132. Raymond Nyhan,
 February 14, 1971
133. James J. McElearney,
 July 18, 1971
134. George F. Hicks,
 November 14, 1972
135. John A. Parina, March 31, 1973
136. Robert F. Upp,
 November 23, 1973
137. James P. Desmond, July 1, 1978
138. Zeno J. Contreras, July 16, 1979
139. Herbert M. Osuna,
 July 31, 1980
140. William J. Moore, Jr.
 May 31, 1988
141. John P. Conway May 2, 1991
142. Jerry Eugene Butler, 1993
143. Louis R. Mambretti,
 March 9, 1995
144. Melinda J. (Mindy) Ohler,
 January 13, 2003

San Francisco Fire Department

Firefighter Mindy Ohler
1956 - 2003

To date, 144 San Francisco firefighters have died in the line of duty. Their names are inscribed on a black granite wall at the SFFD headquarters building at 698 Second Street. The most recent fatality was firefighter Mindy Ohler, Engine 42, who died at the young age of 47 in January 2003, when she fell off the engine responding to a call at San Francisco International Airport. The alarm was later cancelled. She was the first woman to die in the line of duty.

BIBLIOGRAPHY

Anonymous. *Historic San Francisco Firehouses*. SF: SFFD Museum, 1982.

Anonymous. *History of the SFFD: The Exempt Firemen of San Francisco, 1849–1900*. SF: Commercial Publishing Company, 1900.

Burks, John and George Hall. *Working Fire: The San Francisco Fire Department*. Mill Valley: Squarebooks, 1982.

Bowlen, Frederick J. *Fire Horses: Farewell, Good and Faithful Servants*. 1938.

Condon, Emmet and Gladys Hansen. *Denial of Disaster: The Untold and Photographs of the San Francisco Earthquake and Fire of 1906*. 1989.

Holdredge, Helen. *Firebelle Lillie: Life and Times of Lillie Coit of San Francisco*. 1967.

Kenoyer, Natlee. *The Firehorses of San Francisco*. Westernlore Publishing, 1971.

Lynch, Jeremiah. *Senator of the Fifties: David C. Broderick of California*. 1911.

Paul, Caroline. *Fighting Fire*. St. Martins Press, 1998.

San Francisco Fire Department Museum. http://www.sffiremuseum.org.

San Francisco Fire Engine Tours and Adventures. http://www.fireenginetours.com.

Williams, David A. *David C. Broderick, A Political Portrait*. 1969.

To participate in the Oral History program for retired SFFD members, please email author John Garvey at discusthrower@peoplepc.com. Audio and digital video will be made and donated to the SFFD Museum by author and the Hook and Ladder Society. Together let's preserve more SFFD history and retain our unique stories for future generations.